Best Wishes,
Preston Russell

Savannah
2003

THE LOW COUNTRY: FROM SAVANNAH TO CHARLESTON

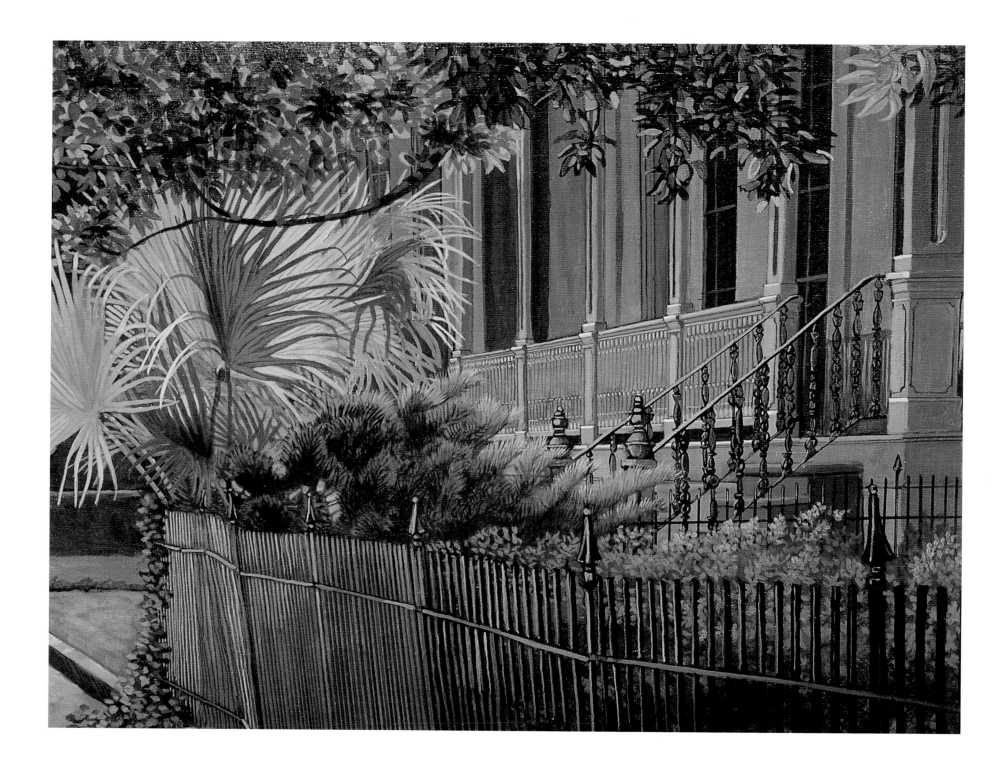

THE LOW COUNTRY: FROM SAVANNAH TO CHARLESTON

PAINTINGS BY PRESTON RUSSELL

Foreword by West Fraser

Author: Preston Russell

Designer: Kathleen C. Bolch

Publisher: C & C Offset Printing Co., Ltd.
Printed in China

All illustrations are the work of Preston Russell

Library of Congress Control Number: 2003091206

ISBN 0-615-12366-X

Dedicated to my children, Lindsay and Alex

West Fraser,
typically
engrossed
in capturing
his legendary
landscapes

FOREWORD

Preston Russell is a large man. Often upon meeting ones who tower over my bald pate, I am struck by their gentle nature. Preston is a gentleman. He is also engaging with his intellect, curiosity and humor. Over the past years, I have come to appreciate him as a friend, and look forward to the insights and perspectives that come to light in our discussions of painting and art. Preston develops a painting around his world view, infusing the regional history that adsorbs him so much. He captures his world by weaving his own personality and style into the images, creating paintings that are far greater than snapshot depictions, so often seen with representational work.

We both paint visions of the southeast coast, a region I was born into, and made the focus of my main body of work. This region chose Preston, and he has become an important participant in the living collective conscious and culture of the place we call home.

— West Fraser 2003

ARTIST'S STATEMENT

What a visual feast to live in the low country. American by birth—*southern* by the grace of God, as the old saying goes. More and more northerners are discovering this privilege as well, flocking into the area like wildfowl following primal instinct. The low country embraces us all, including myself from Tennessee, which is significantly north of the low country. Most everywhere else is too, exceeding mere geography.

I have been an artist for over forty years, but only became a serious one after I moved to Savannah. The reason I add "serious" is due to the low country alone. When I drove down that first Savannah street in 1972, I saw something very moving—arresting. Old things, things that don't tend to dwell elsewhere in America. Old ways, old traditions. Tradition, someone said long ago, is the living faith of dead people. One can feel it here, even on a visit. After a few years, you know it. Old buildings, many drooping in splendid decay, like elderly folks who become more beautiful with the patina of survival. These old structures even seem to endow their occupants with an aura, as if an ordinary person walking down a Savannah street seems more real—even extraordinary—compared to that same person walking around the ubiquitous American strip mall. Romantic people in their own peculiar realm, both a part of the other, inseparable, eccentric. John Berendt captured this essence perfectly in his international best seller, *Midnight in the Garden of Good and Evil*:

> The city looked inward, sealed off from the noises and
> distractions of the world at large. It *grew* inward, too, and
> in such a way that its people flourished like hothouse plants
> tended by an indulgent gardener. The ordinary became
> extraordinary. Eccentrics thrived. Every nuance and quirk of
> personality achieved greater brilliance in that lush enclosure
> than would have been possible anywhere else on earth.

Progressively, I became compelled to record this vision, in a committed way. This is what I mean by serious, not me—but *it*—the subject, which is the low country and her people, demanding my respect. Recalling Gertrude Stein's famous observation, there is definitely a "there" here—magic—and in Charleston, in Beaufort, in Bluffton, the Golden Isles, and other places I have yet to discover. And when I do discover them, often by chance, I feel excitement and humility, indeed awe, confronting a chance revelation of the "there" which is here. If successful in capturing that fleeting *there-ness*,

I am privileged to share in a degree of timelessness, a moment of grace that the subject alone gives—before it darts off—never to be quite the same forever. What will life permit me to observe tomorrow? A far greater artist, Andrew Wyeth, expressed this visual quest better than I can:

> I think one's art goes as far and as deep as one's love.
> I see no reason for painting but that. If I have anything
> to offer, it is my emotional contact with the place where
> I live and the people I do.

6

SAVANNAH & CHARLESTON

At a casual glance, Savannah and Charleston have a similar persona:
old cities, antique compared to most of the country. Both escaped the
rebuilding orgy after the Second World War, when city fathers competed
in exuberant Modernism—leveling the Old to make way for Progress.
For too many Americans, this has resulted in interchangeable
futuristic blandness, a sterile tapestry of efficiency. Old was
not charming or alluring then, just old, decrepit, and seedy:
Bigger, newer, better was the American dream.

In spite of their visual similarity, Charleston and Savannah are
different in character. One exudes serene grandeur, little
changed since the American Revolution. The other reflects a
more eclectic history of perseverance. So close in time
and distance, yet so far apart in experience. Historic Charleston
often projects the swagger of her fictional native son,
Rhett Butler. The historic Savannah look is more repetitive,
in human scale. One city appears open, while the other
suggests reserve: bustling communal squares versus
haunting old streets with imposing facades.

Both cities can be insular and eccentric, reflecting a fierce collective
memory of who they are because of who they were. The roots of
their founding linger, never forgetting the ghosts who reside in the
parlor. Now most Americans would covet dwelling in either place,
and their instinct would be right, seeking a romantic difference.
Savannah and Charleston are fragile living dreams.

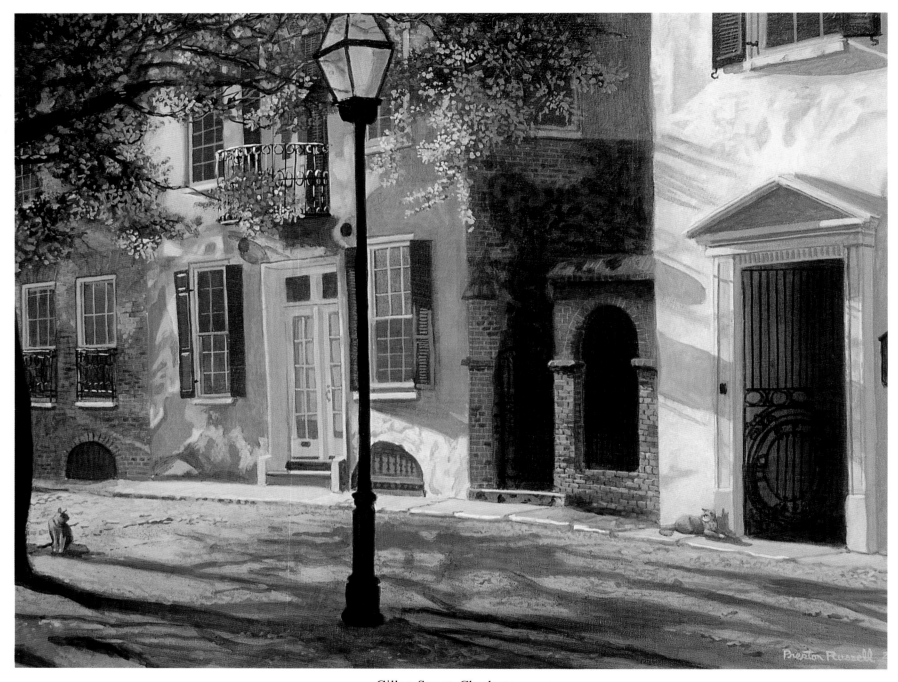

Gillon Street, Charleston

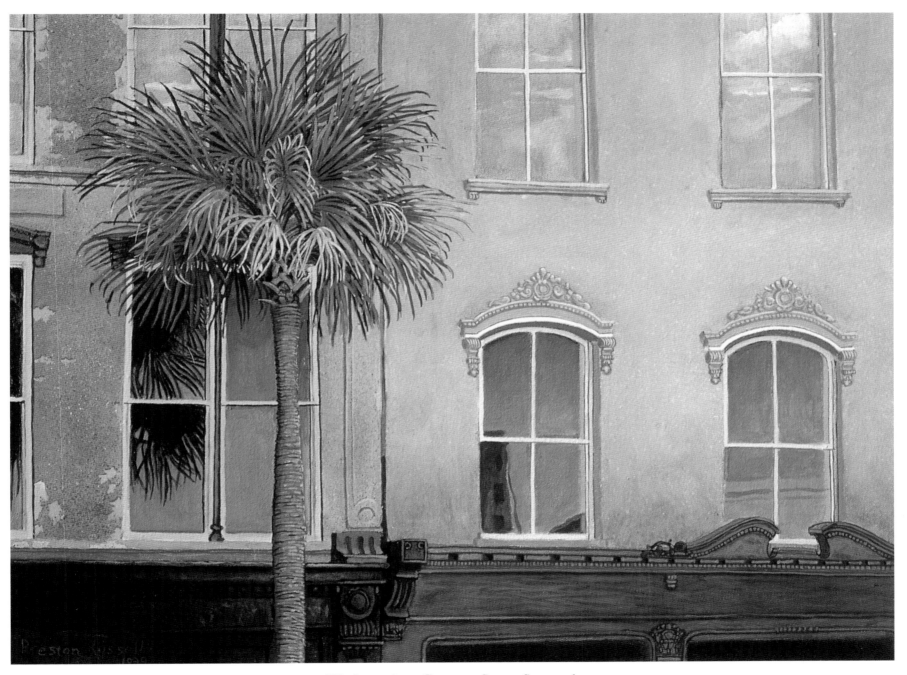

Windows along Congress Street, Savannah
Collection of Mr. & Mrs. Greg Parker, Savannah

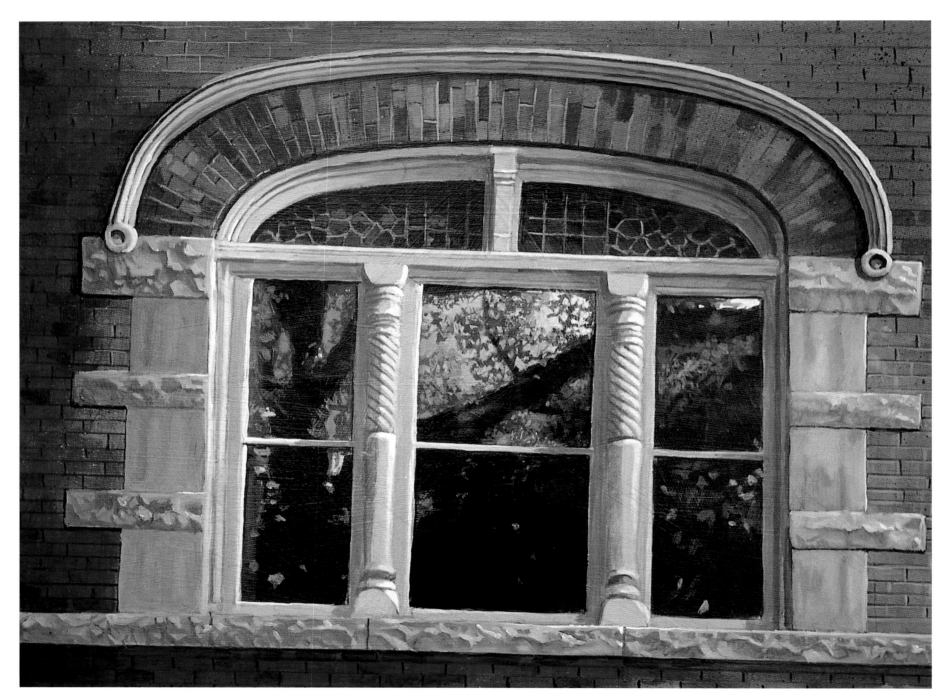

Window on Jones Street, Savannah

10

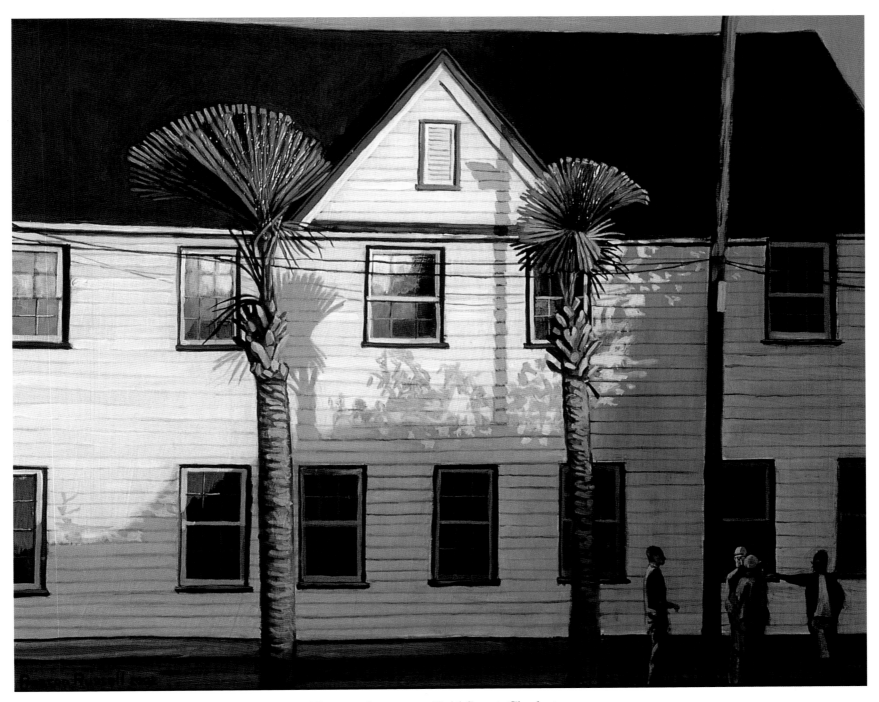

Young palmettos on Reid Street, Charleston

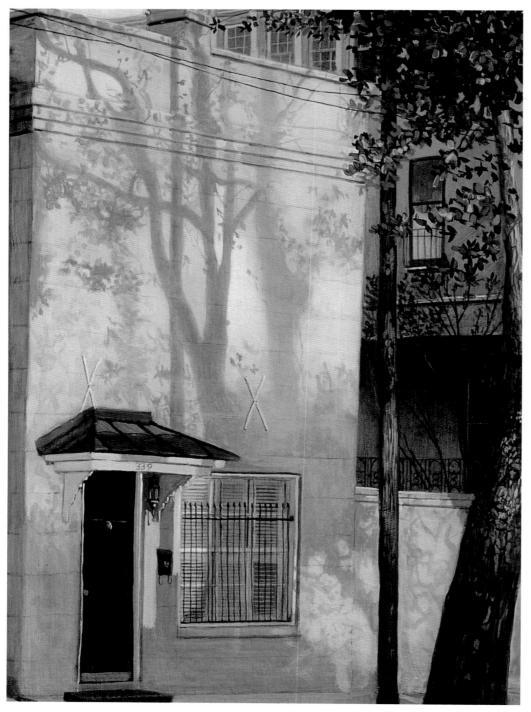

Morning shadows on Barnard Street, Savannah
Collection of Mr. Paul Nix, Atlanta

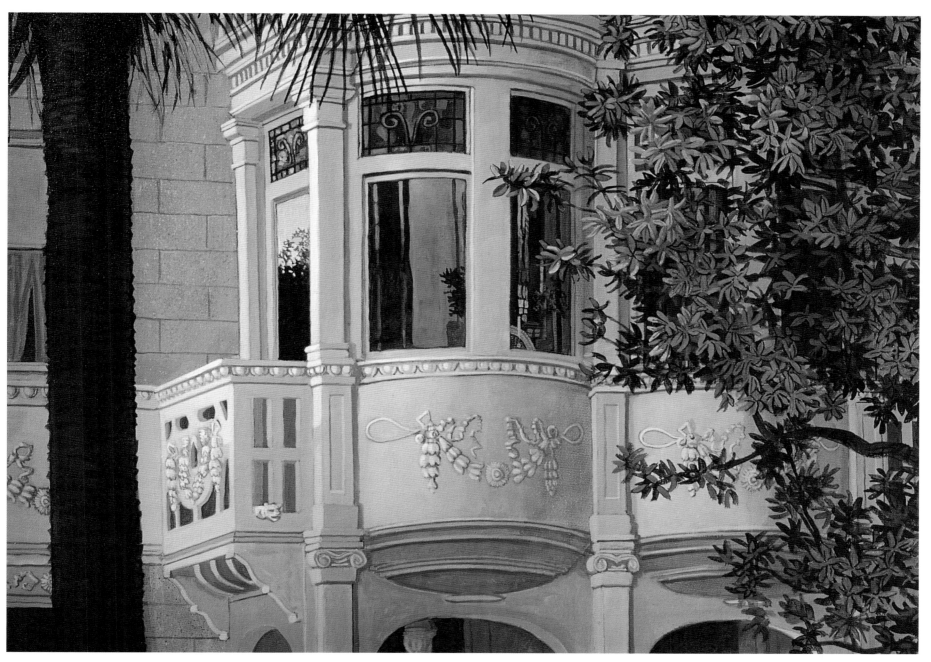

Bay window on Taylor Street, Savannah
Collection of Dr. & Mrs. John West, Savannah

13

Morning light on Houston Street, Savannah
Collection of Mr. & Mrs. Michael Crowley, Savannah

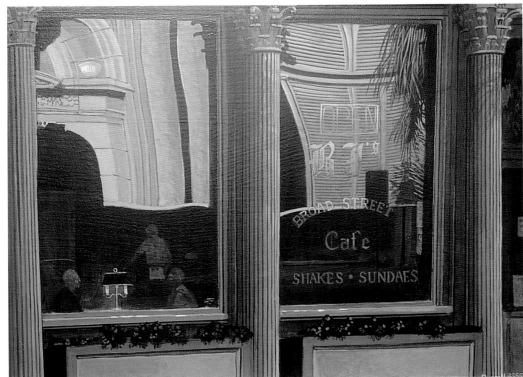

Reflections from B.J.'s Restaurant, Broad Street, Charleston

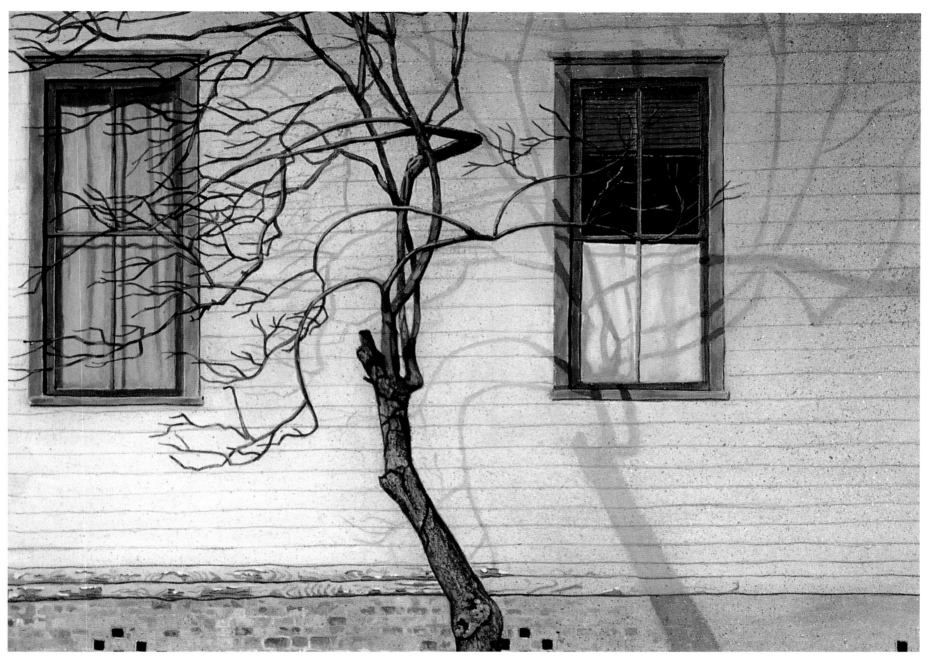

Tree in winter, off Habersham Street, Savannah
Collection of Dr. & Mrs. Peter Scardino, Jr., New York

15

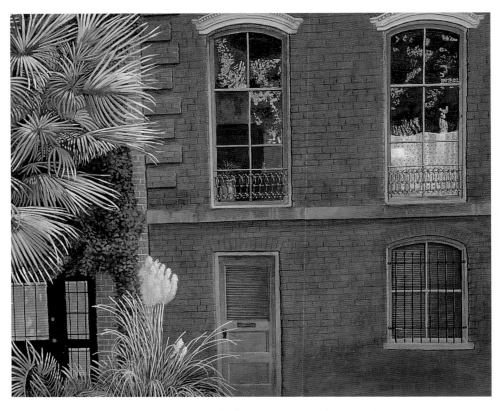

Windows on Oglethorpe Avenue, Savannah
Collection of Mr. & Mrs. Graham Sadler, Savannah

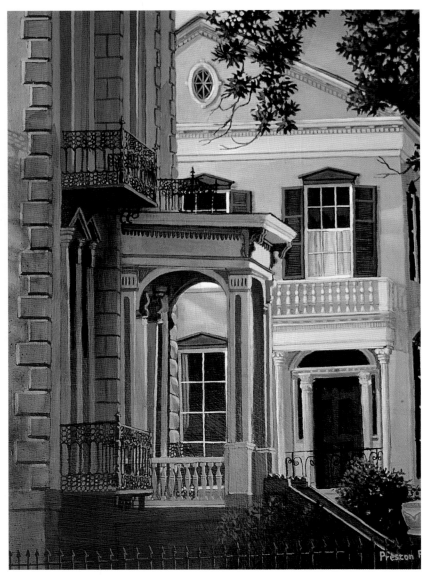

Hamilton Turner house, with Charlton Street
in background, Savannah

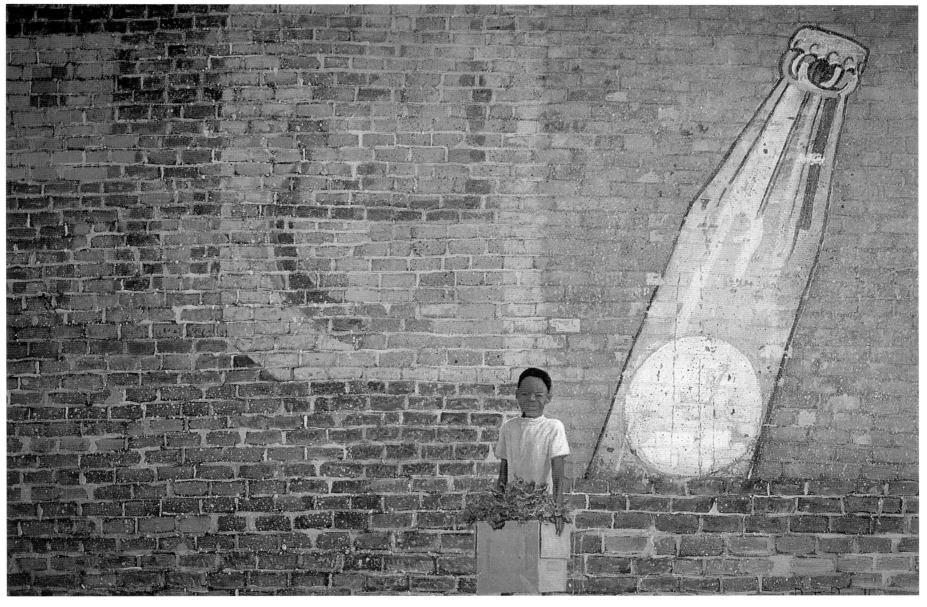

Boy and fading drink sign, Perry Street, Savannah, 1970's
Like a fading Byzantine mosaic, this image is disappearing after half a century, seldom noticed by those who race past down Price Street.
Original version in the collection of Mr. & Mrs. James C. Bradford, Jr., Nashville

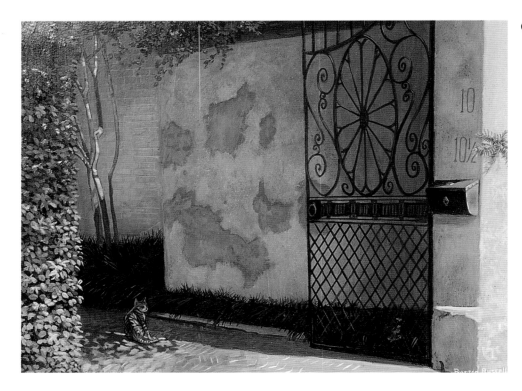

Cat and shadows on Legare Street, Charleston

Young cat on York Lane, Savannah, 1970's
*Original version in collection of Mr. & Mrs. James Syprett,
Sarasota, Florida*

18

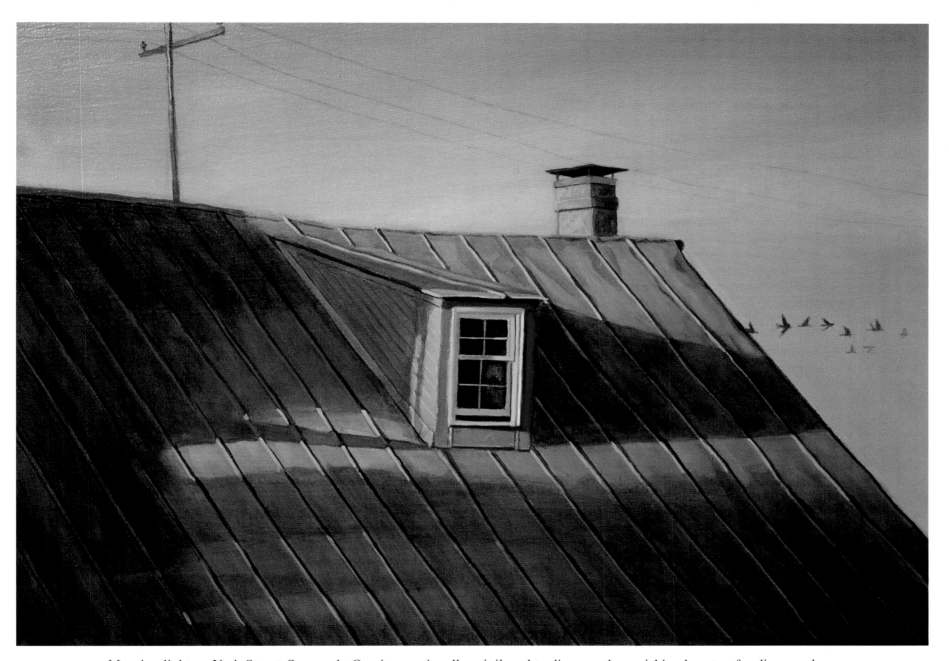

Morning light on York Street, Savannah. One is occasionally privileged to discover the ravishing beauty of ordinary colors, but the quality of light defines everything. At mid-day, there is nothing magic, only glare and heat.
Original version in collection of Mr. & Mrs. Bill Ottinger, Chicago

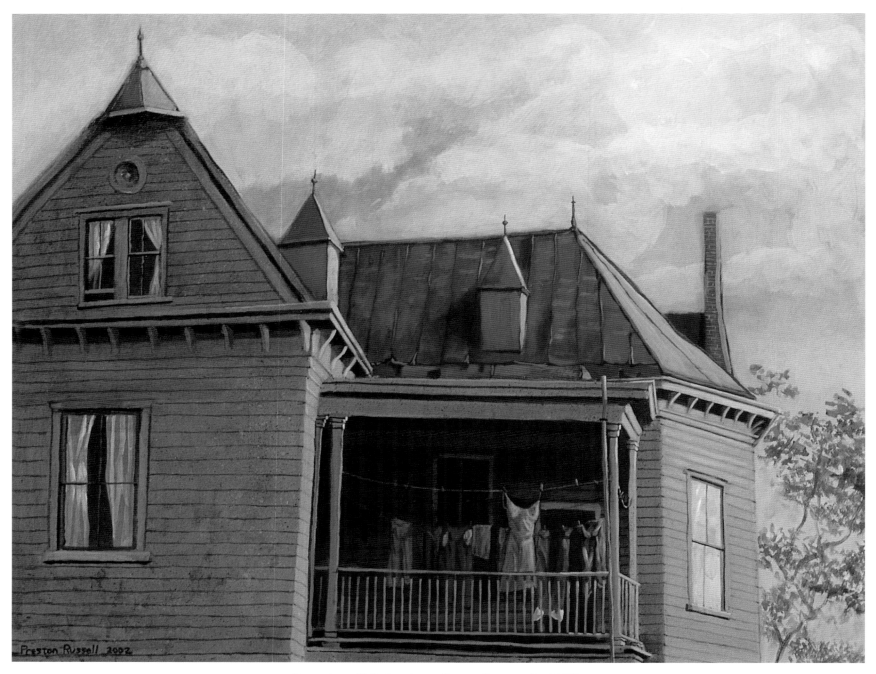

Laundry off Habersham Street, Savannah, 1970's
Original version in the collection of Mr. & Mrs. Rodman McLeod, Savannah

20

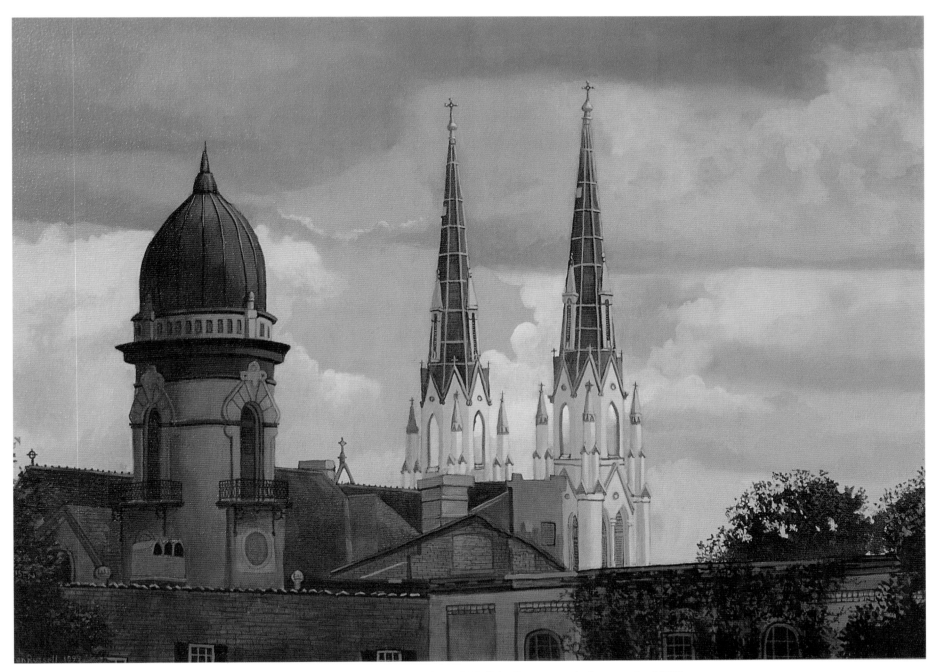

Steeples of Cathedral of St. John, old jail in foreground, Savannah, 1980's
Collection of Dr. & Mrs. John Duttenhaver, Savannah

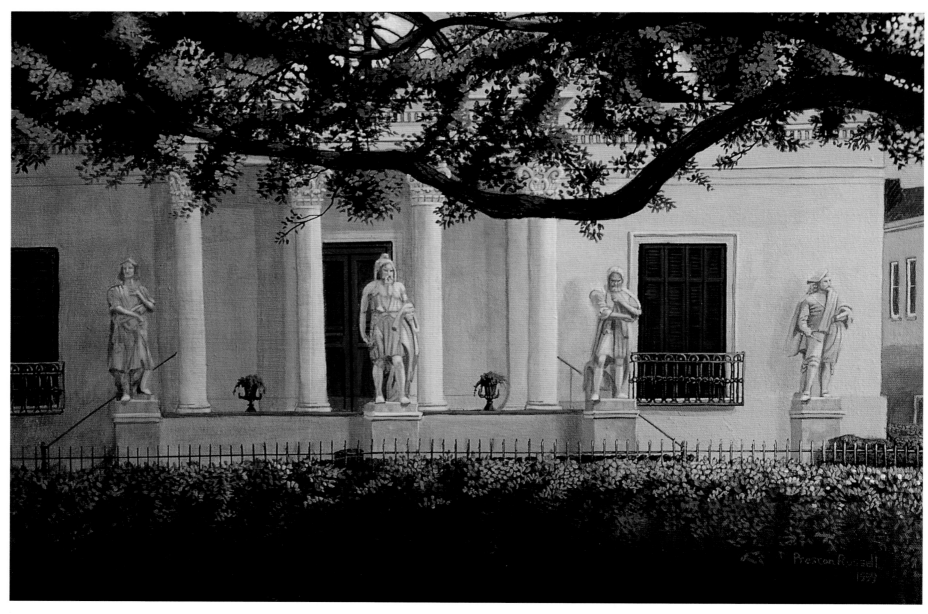

Telfair Museum, Savannah
Collection of Mrs. John Luck, Savannah

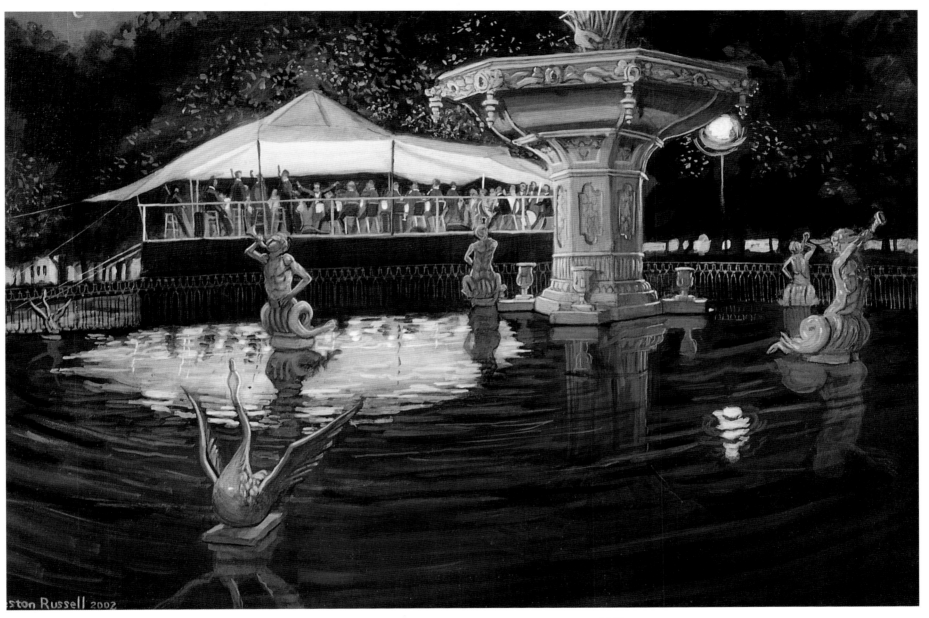

Savannah Symphony in Forsyth Park, Savannah, 1980's

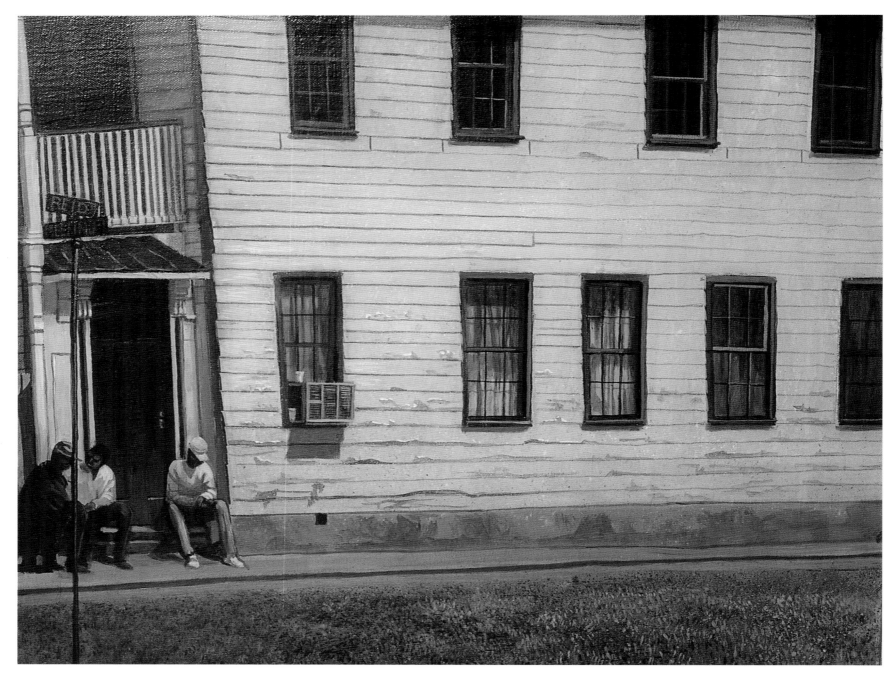

Corner of Reid and Meeting Streets, Charleston

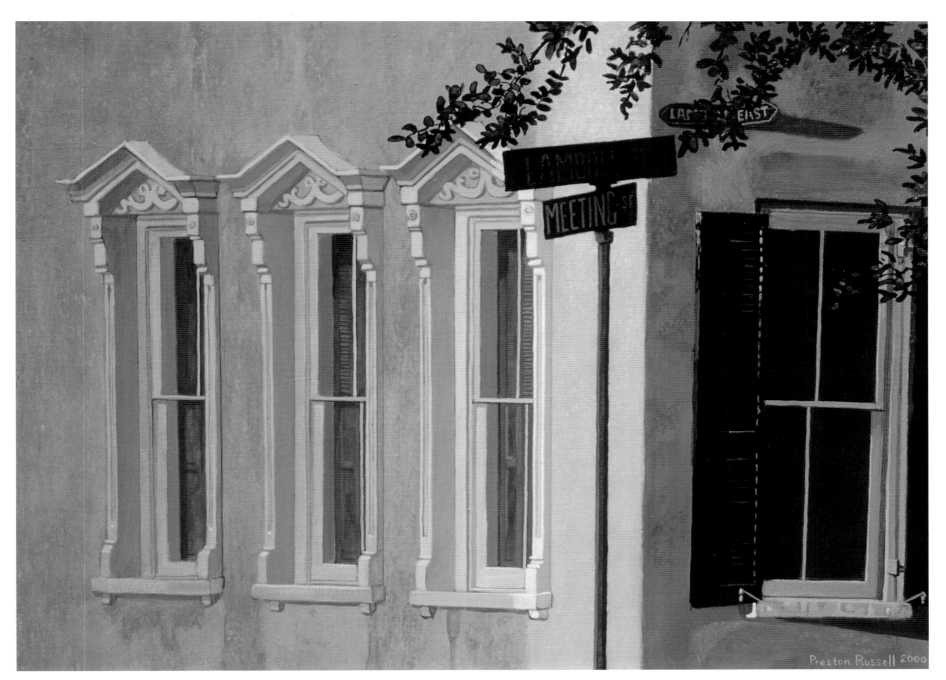

Early morning on Meeting Street, Charleston

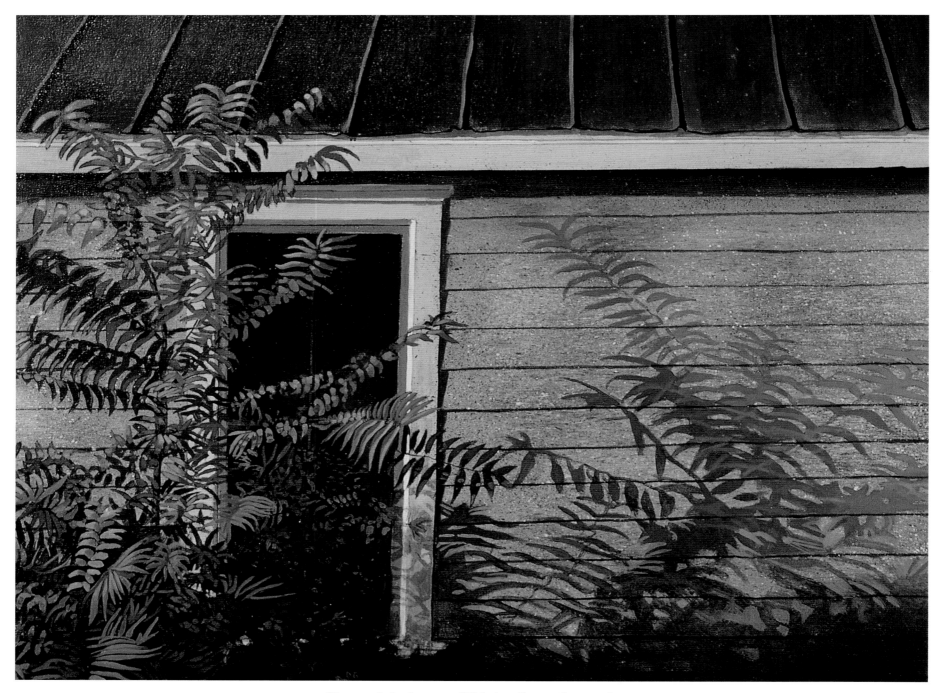

Plant and shadows on Whitaker Street, Savannah

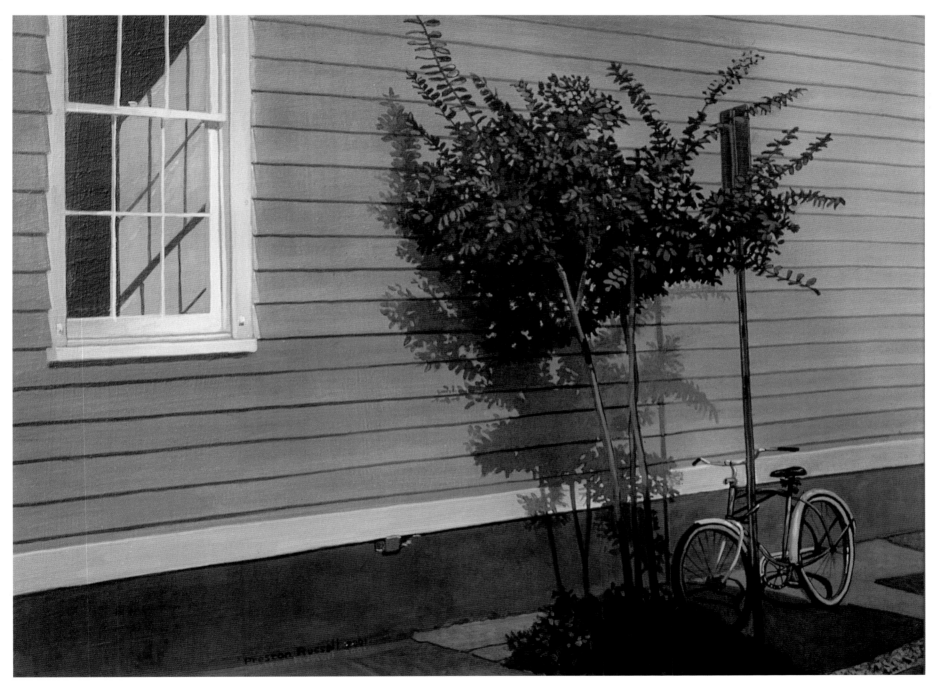

Limehouse Street, Charleston

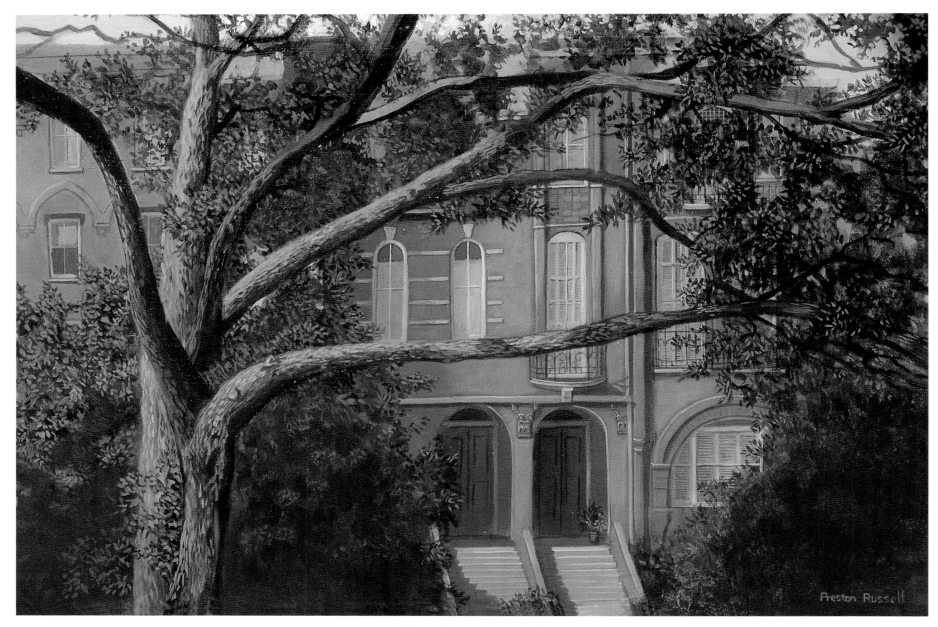

Gaston Street, Savannah

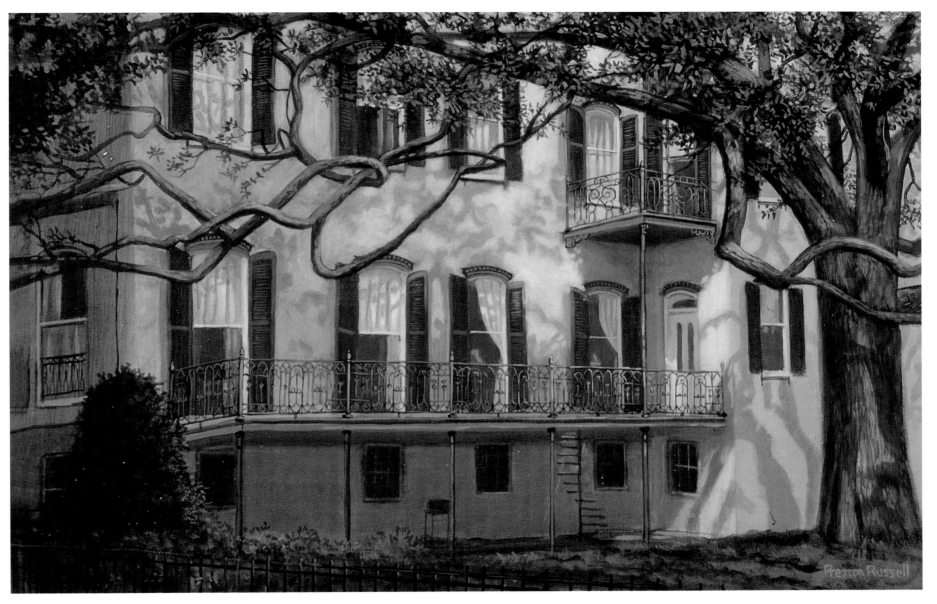

Hall Street, Savannah

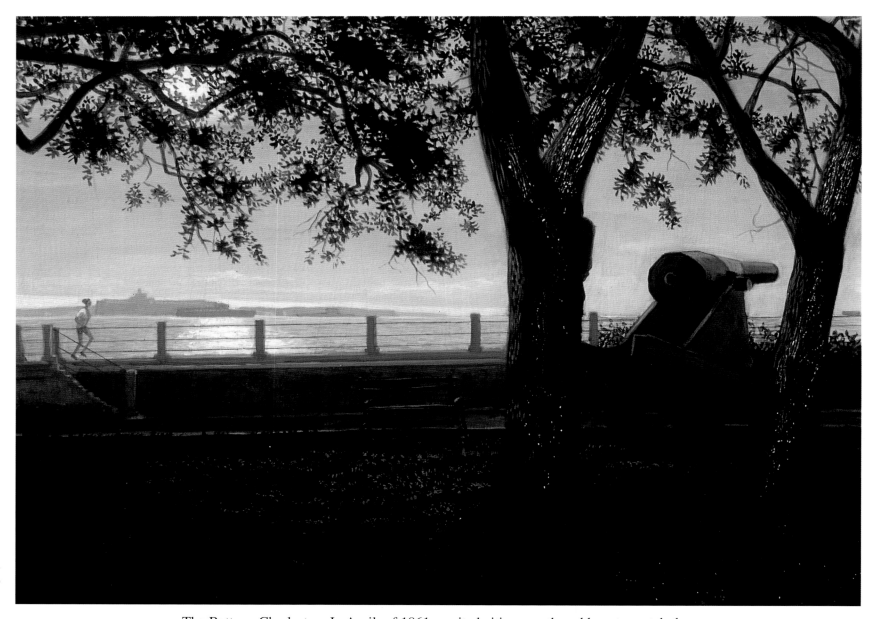

The Battery, Charleston. In April of 1861, excited citizens gathered here to watch the
bombardment of Fort Sumter on the horizon, officially beginning the Civil War.
Original version in the collection of Dr. and Mrs. Burton Goodwin, Savannah

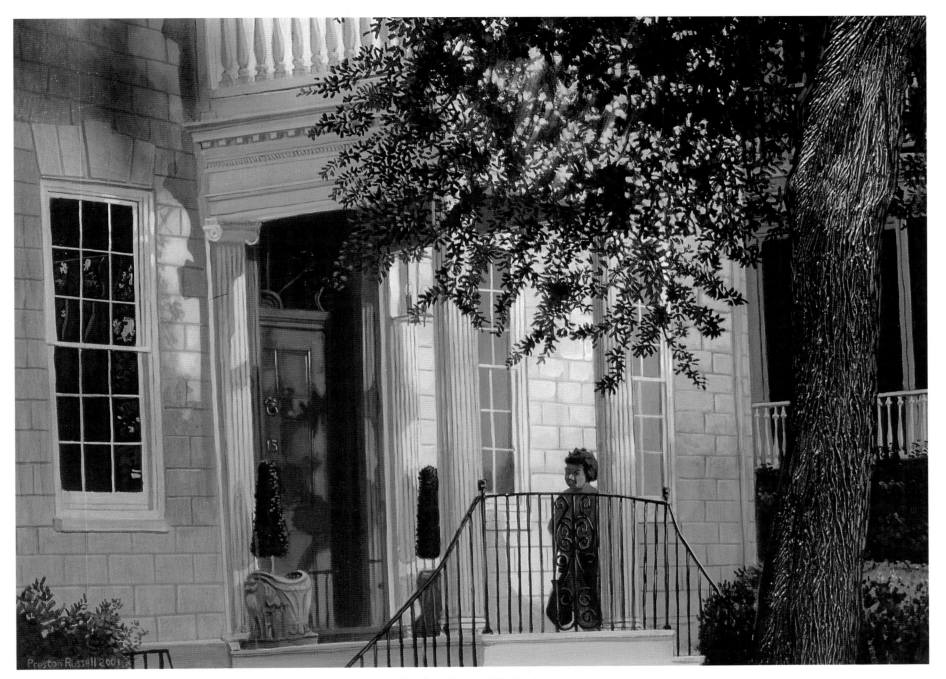

Meeting Street, Charleston

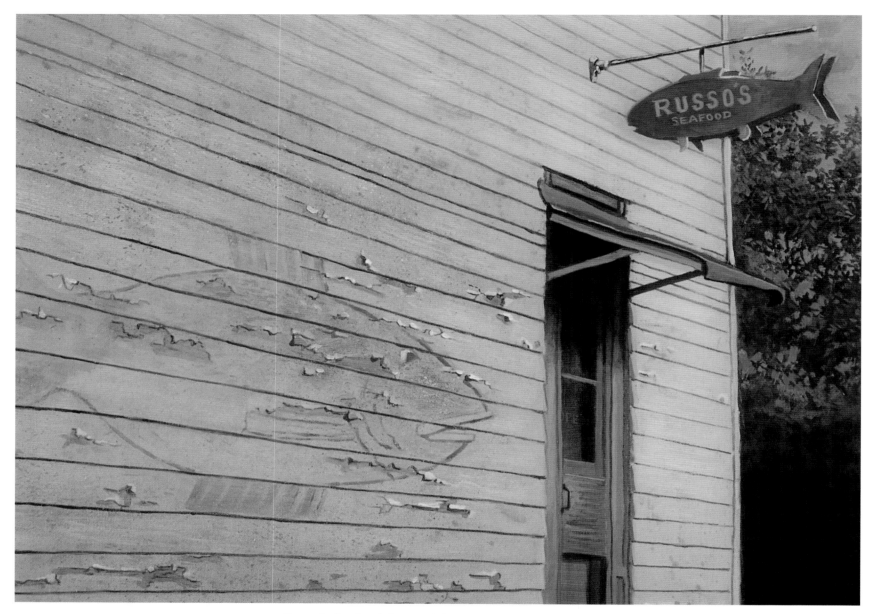

Russo's Seafood, Barnard Street, Savannah, 1970's
This fish has been a repeated subject of mine, although the building was demolished years ago. Not intended as folk art, it achieved that special status, expressing joy, strength, and innocence. Whatever the emotional expression of the fish is—that indefinable something—cheers me up, gives me hope as I return to this same subject, again and again.
Other versions in the collections of Mr. & Mrs. Bob Long, Atlanta, and Dr. & Mrs. Roland Summers, Savannah

SURROUNDINGS

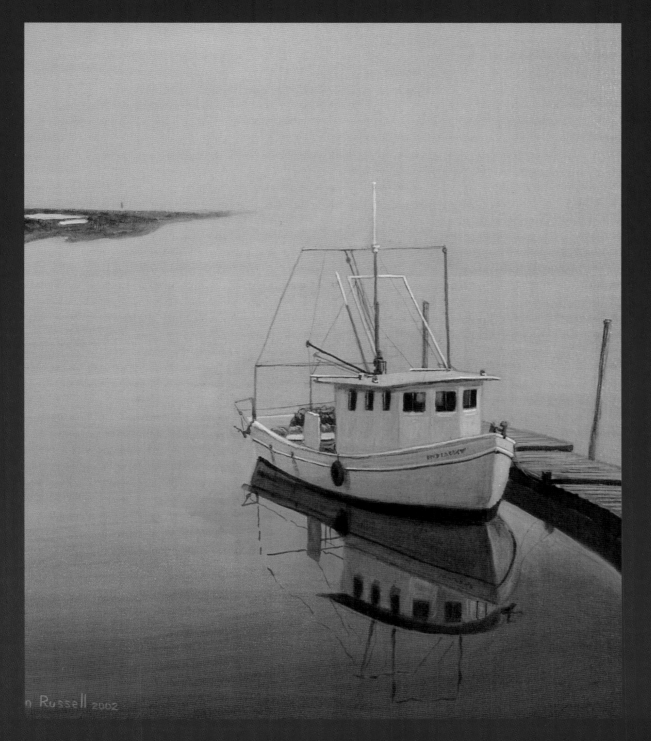

Depicting low country surroundings usually means a diet of marshes, beaches, and seductive inland waterways. These are regional delicacies, no less than roasted oysters, boiled shrimp, and steamed crab. I have learned that I can add little to many fine artists who already capture these aspects, so I usually don't try. Yet I could not resist over the years dabbling in a bit of regional flora, fauna, and ambience. As in this shrimp boat on an inland waterway, sometimes the water can go on forever, making everything seem on the edge of eternity.

Following Pages:
Container ships and tugboats on Savannah River. It is impossible to exaggerate how enormous these vessels can be, both in reality and the awesome feeling when one passes by, like a mobile mountain.
Commission for cover of Savannah Magazine

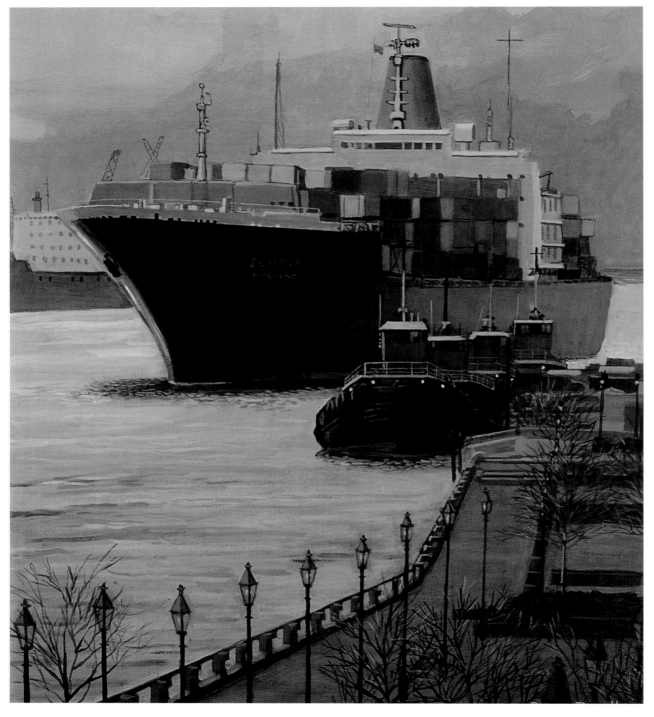

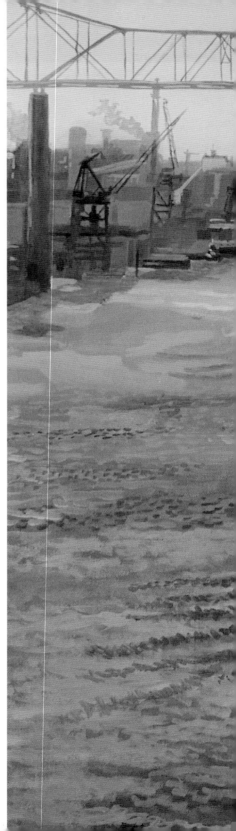

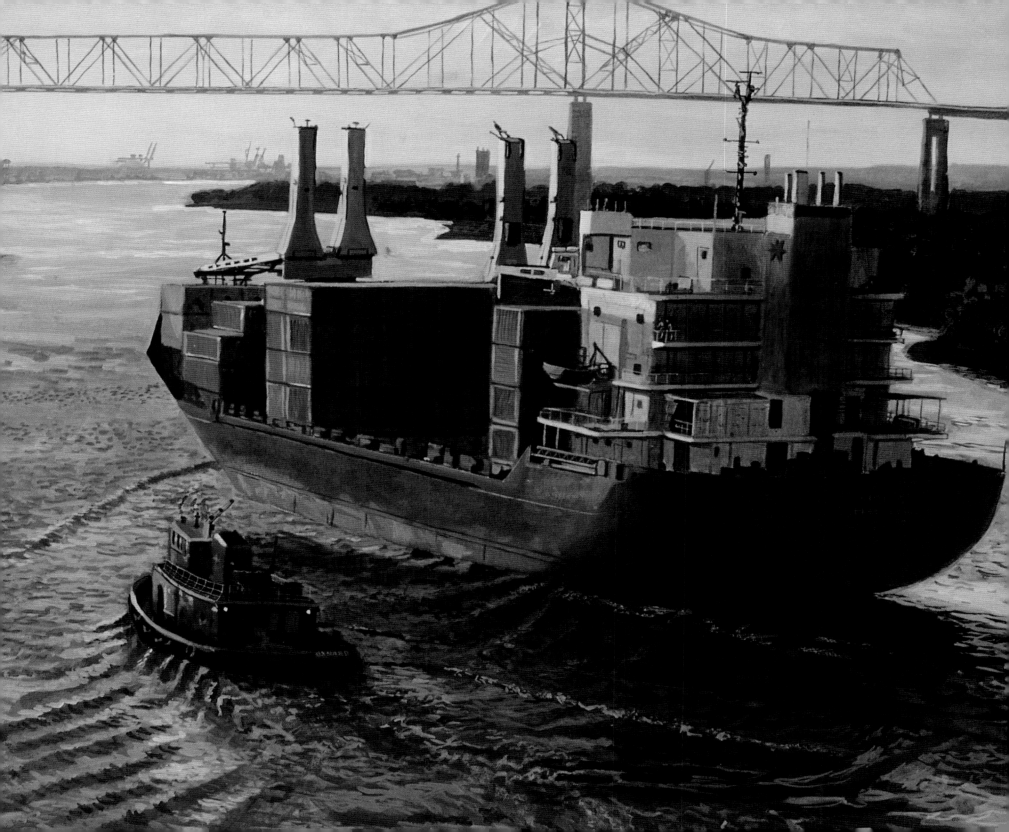

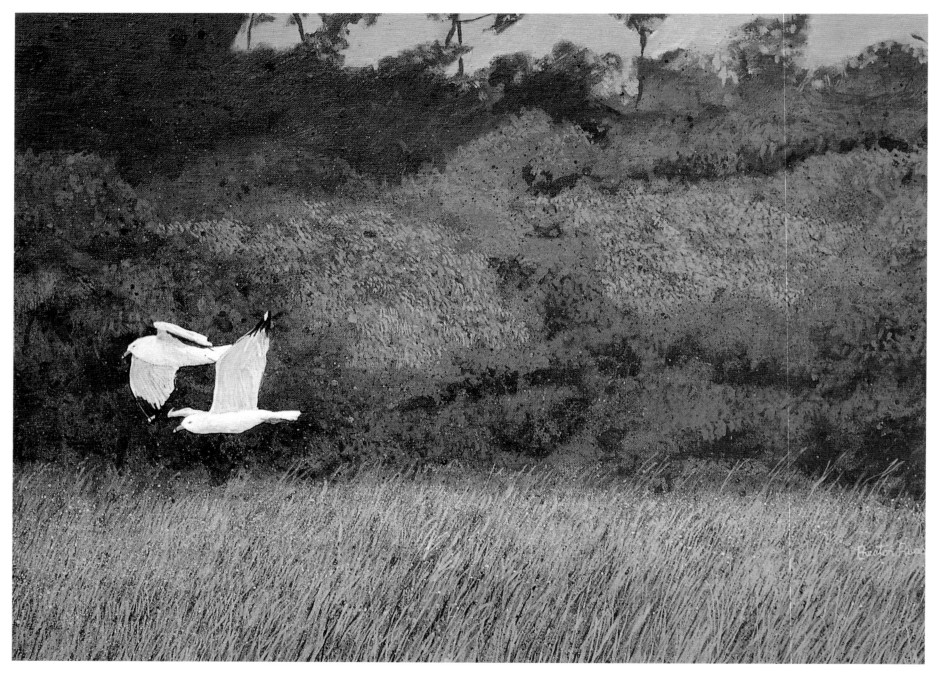

Two sea gulls on Hilton Head, South Carolina

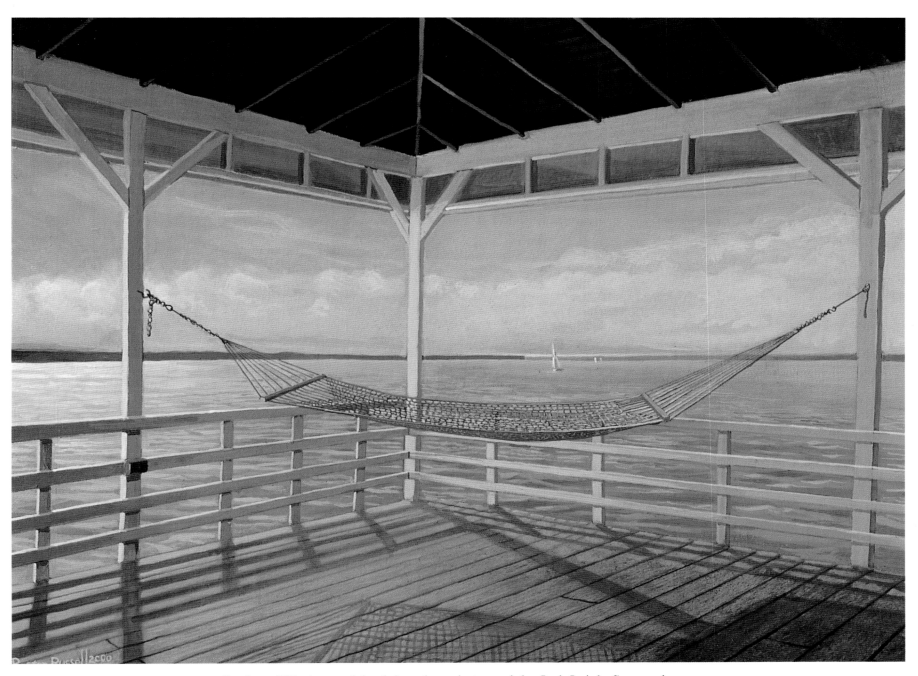

Dock on Wilmington Island, based on photograph by Jack Leigh, Savannah
Collection of Mr. John Cay, III, Savannah

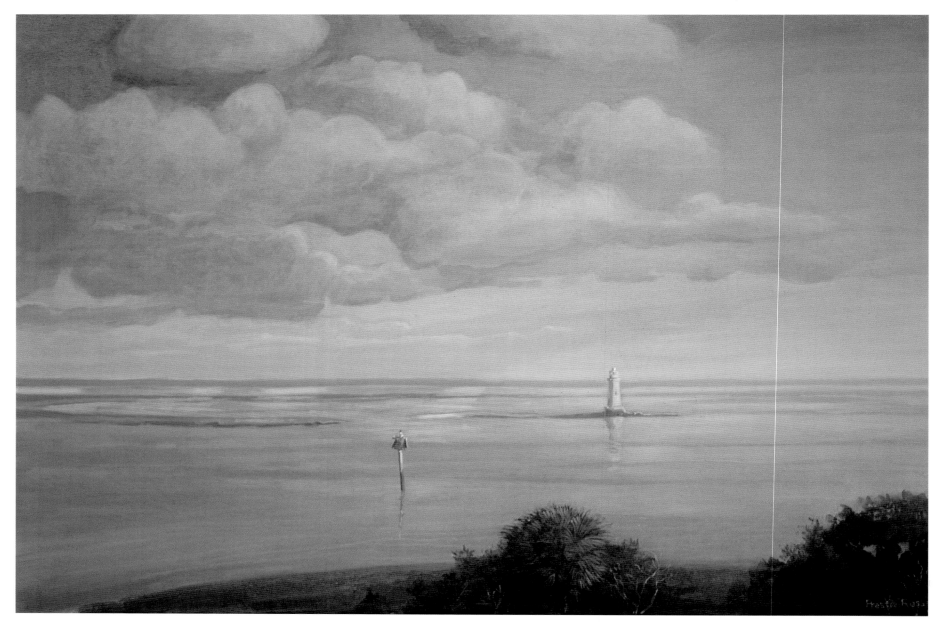

Abandoned lighthouse

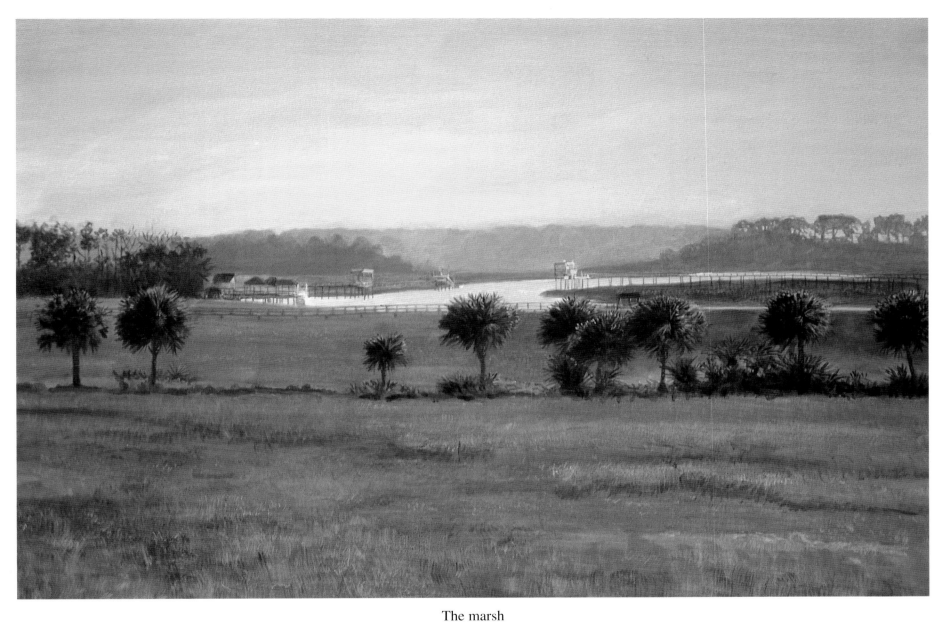

The marsh

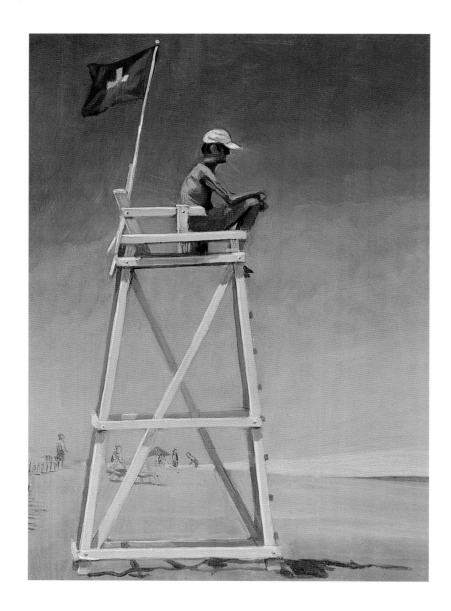

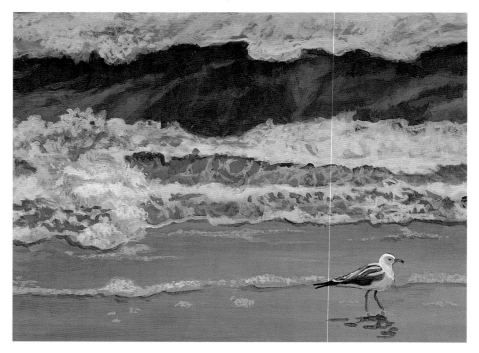

Collection of Mr. Gus H. Bell III, Savannah

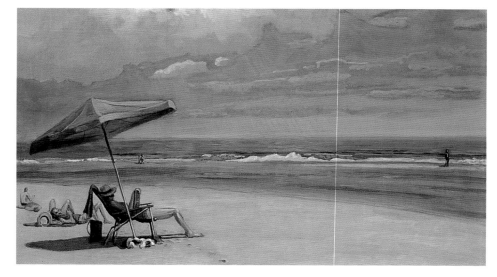

Collection of Ms. Meredith Kay Repella, New York

Beach Scenes

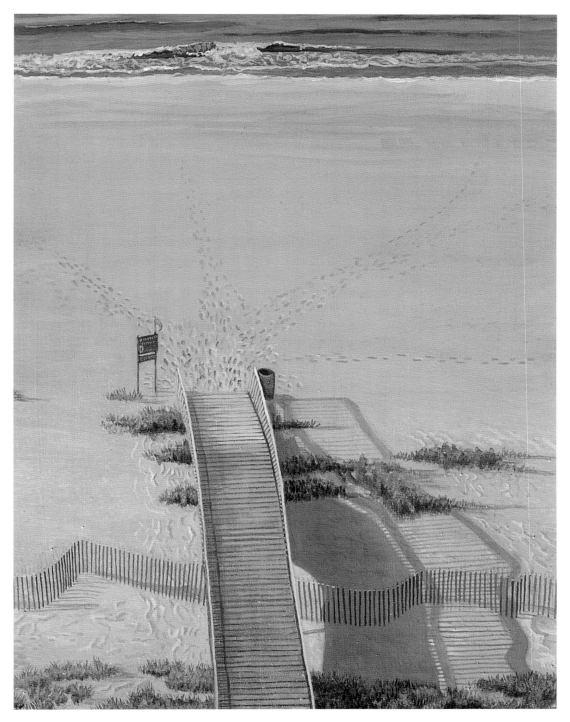

Out to the beach

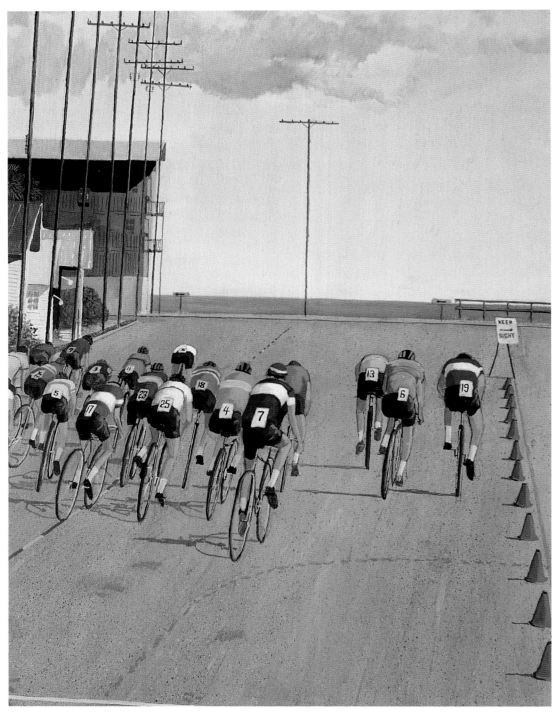

Bicycle race on Tybee Island, 1970's
Collection of Mr. & Mrs. Lawrence Dunn, Savannah

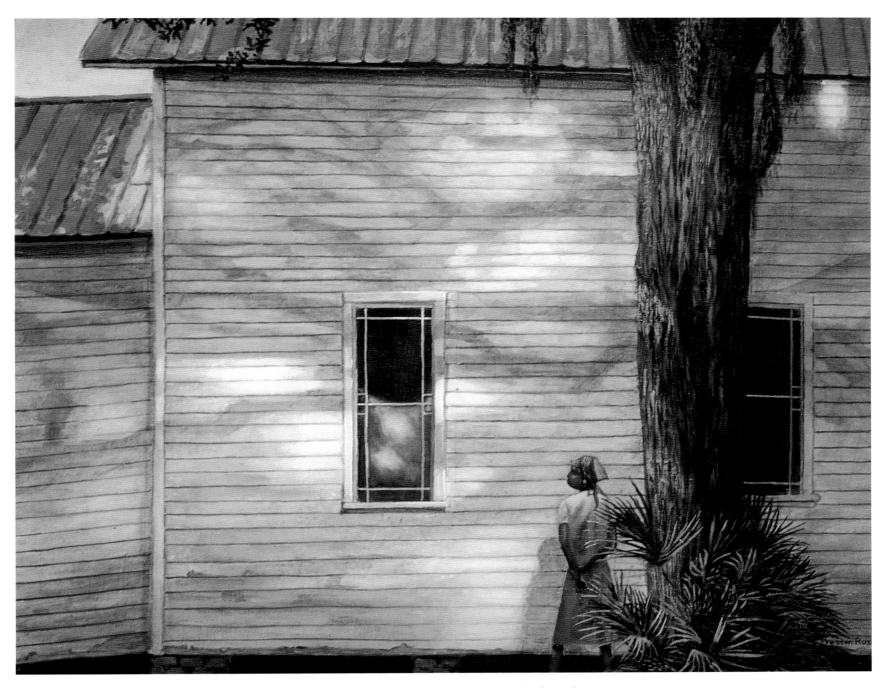

Woman and old church, Sapelo Island, Georgia
Collection of Mr. & Mrs. Charles H. Morris, Savannah

Georgia red clay, from Savannah to Augusta
Collection of Mr. & Mrs. Neal Cory, Louisville, Kentucky

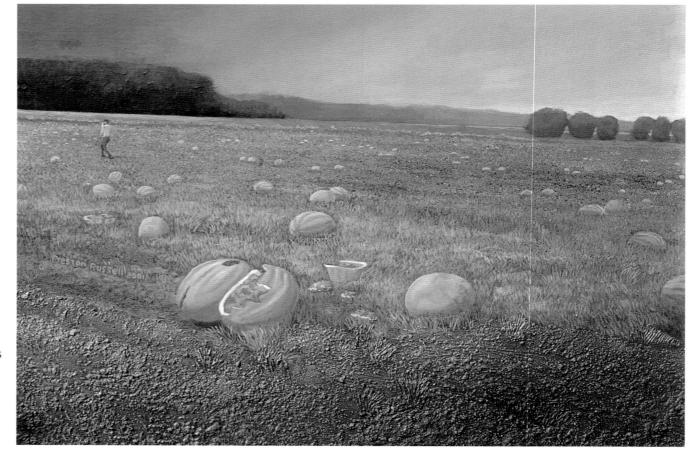

Watermelon field in South Carolina
It was a very hot day, and a storm was brewing in the distance. Electricity filled the air, coming. The melons looked in distress, as if they had just faced slaughter. I sensed menace and tension, and painted it accordingly.

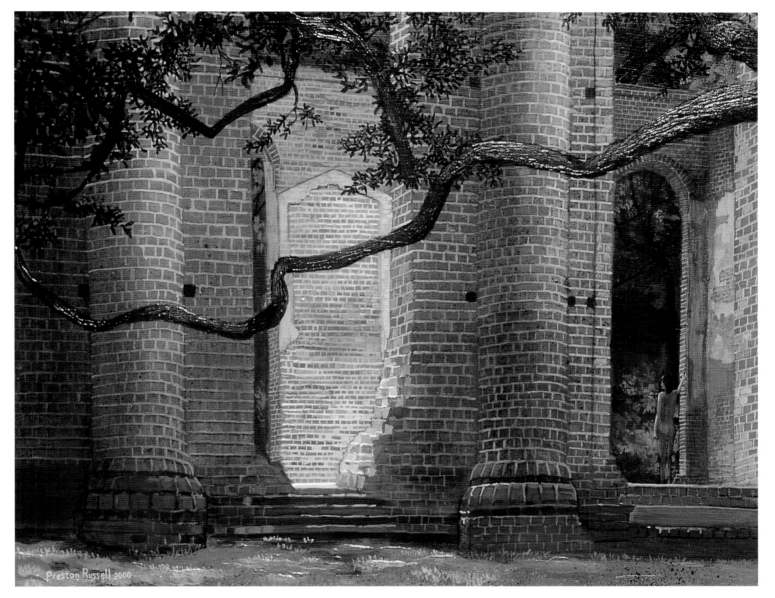

Old Sheldon Church, off Highway 17 to Charleston

Built in the 1760's, this magnificent structure was burned by the British during the American Revolution, then by the Union during the Civil War. The church seems very far away from anywhere, and was especially so before the automobile or modern roads. Yet, for more than two centuries, some of the finest low country families made the Sunday trek, which meant a day's commitment, even from nearby Beaufort. Some of them, like the 18th century Bull family, lie in the small graveyard there. Special services continue to be held there, including occasional weddings. Adding the nude woman was some unexplainable afterthought, but somehow she seemed appropriate there, like Eve.

INTERIORS

Interiors have their own integrity and are distinct from exteriors.
Rooms can be like a womb, a place of privacy. There is more intimacy,
personality, contrasts of light and dark. Interiors are full of revelations,
but also mysteries. Who is that woman in the antique portrait on the
far wall? Why that photo on the desk? Who are they? Do they somehow
live here too? Residents would answer yes, they live here along with
the furniture and other heirlooms, all friends. These make their house
their home, where once it may have been the home of someone
else, someone with different friends.

Beyond the voyeuristic aspects of interiors, they can be anonymously
seductive. Outside the windows sunlight and nature beckon to come in,
but inside, the light plays on wood, fabric, books, the dark hallway, the
coming, the going, the revealed and the secret home. Who *really* lives
here? Occasionally the very personal becomes universal: we do.

This particular house in Savannah was in the process of restoration. I do
not know why this lonely chair expresses so much. It is something I had
no control over, which is the excitement of being an artist. Sometimes
you are liberated by the grace of the subject, and you only follow.

Collection of the Morris Museum, Augusta

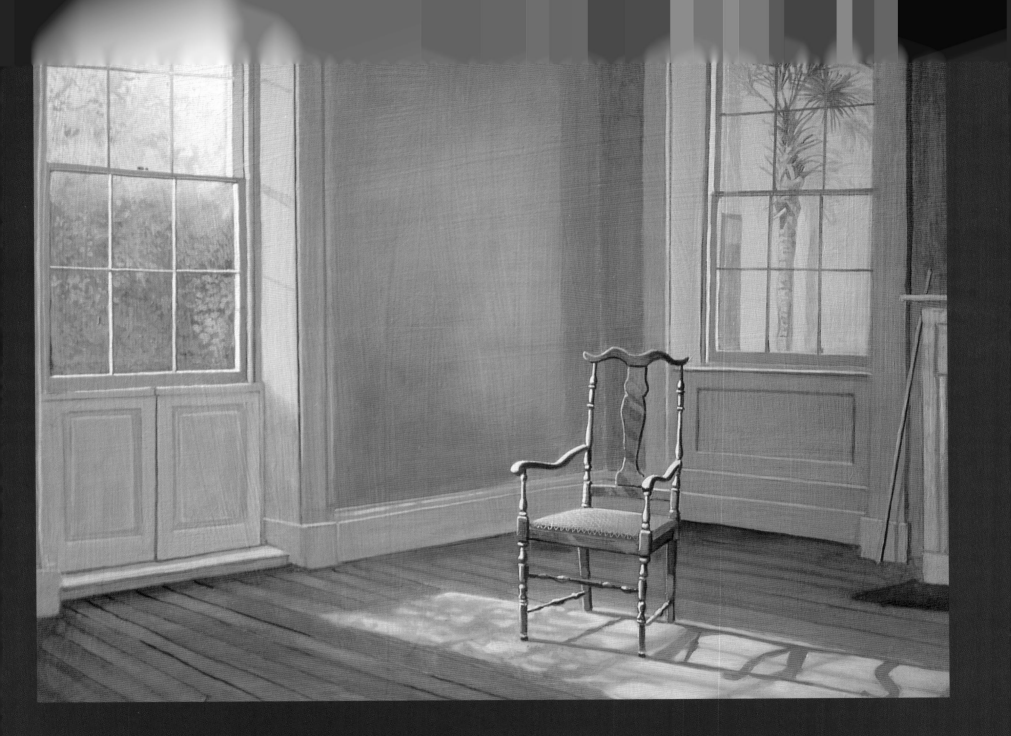

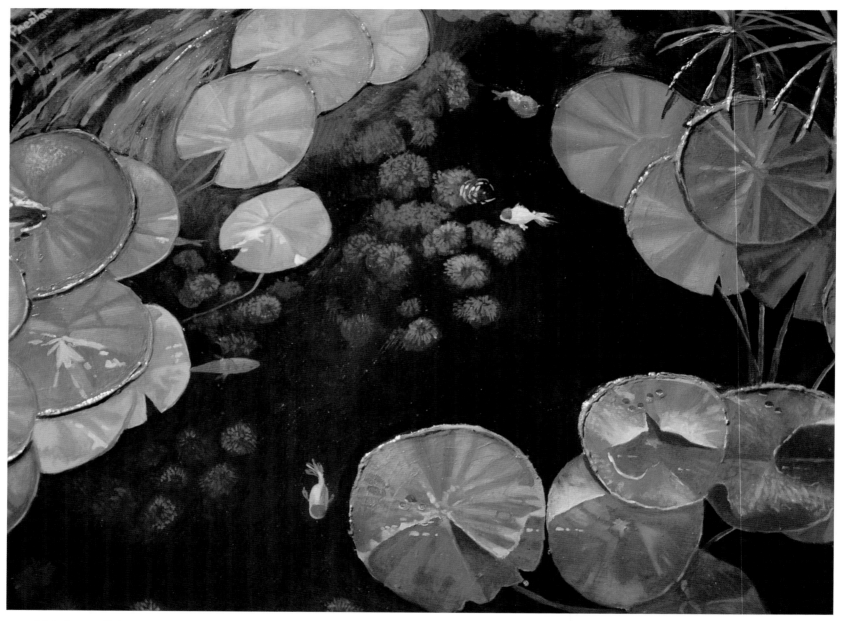

This is our fish pond, the only place in the garden I tend without nagging. My companions are there–or were–my favorites being pretty "Red Cap" Arandas, and especially a clumsy orange relative called a Lion's Head. My daughter gave me an extra big Lion's Head for my birthday. Having no dorsal fin, they resemble a swimming beer can, so ugly, lurching and vulnerable as to bring out the most protective parental concern. They are easy prey to predators–even the mere puppy that playfully exterminated them all–whenever their trusting curiosity brings them to the top for companionship. Sadly, this is why the only survivors now are street-savvy orange Comets, the swift ordinary goldfish.

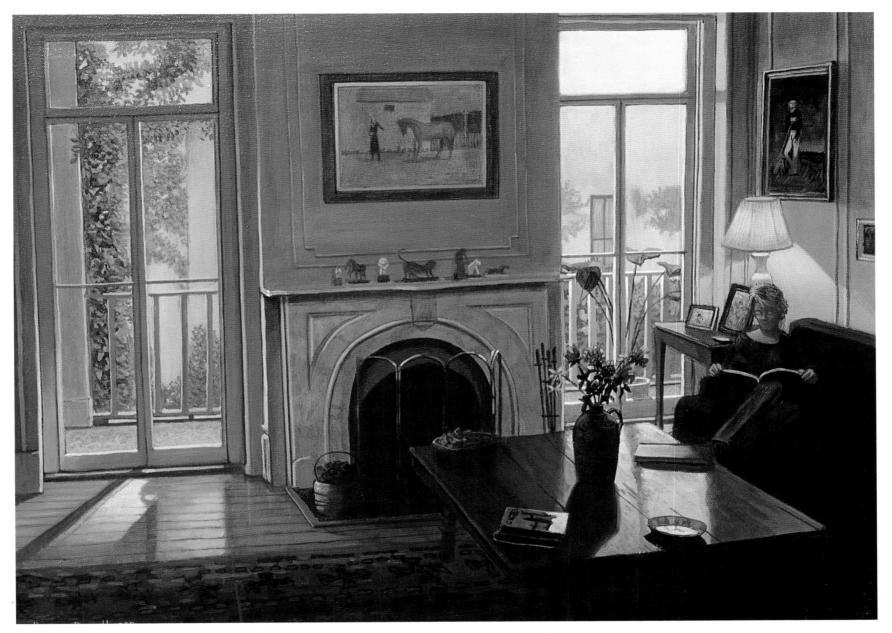

Interior on Gaston Street, Savannah

This is our home, with my wife Barbara on the couch, reading as usual. Our place resembles the asylum of a couple of insane collectors. Like people who collect stray pets, we own five of them too, not counting the goldfish outside. There is always room for one more painting, one more sculpture, *one* more...

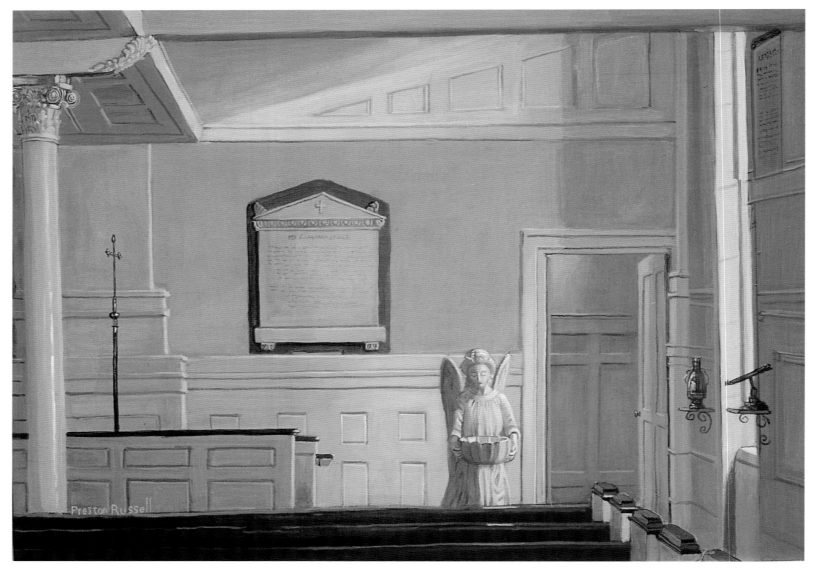

Christ Church, Johnson Square, Savannah

This is the sanctuary of the oldest congregation in Georgia, founded in 1733. The classicism reflects the Anglican roots of that first boat of impoverished Englishmen in the ship *ANNE*, led by James Oglethorpe. The colonists hardly enjoyed this implied grandeur during their early travails, with over half of their number dead after two years, victims of disease and privation. Young John Wesley was an early rector in 1736, consumed by strange fires for an unobtainable woman. Hounded back to England, he spent the rest of his life founding Methodism. The tormented Wesley first "shook off the dust of my feet, and left Georgia, after having preached the Gospel there, not as I ought–*but as I was able*." By the next generation, Royal Governors and the landed prosperous dominated the pews, to the extent that Loyalists to the crown were the trend by the American Revolution.

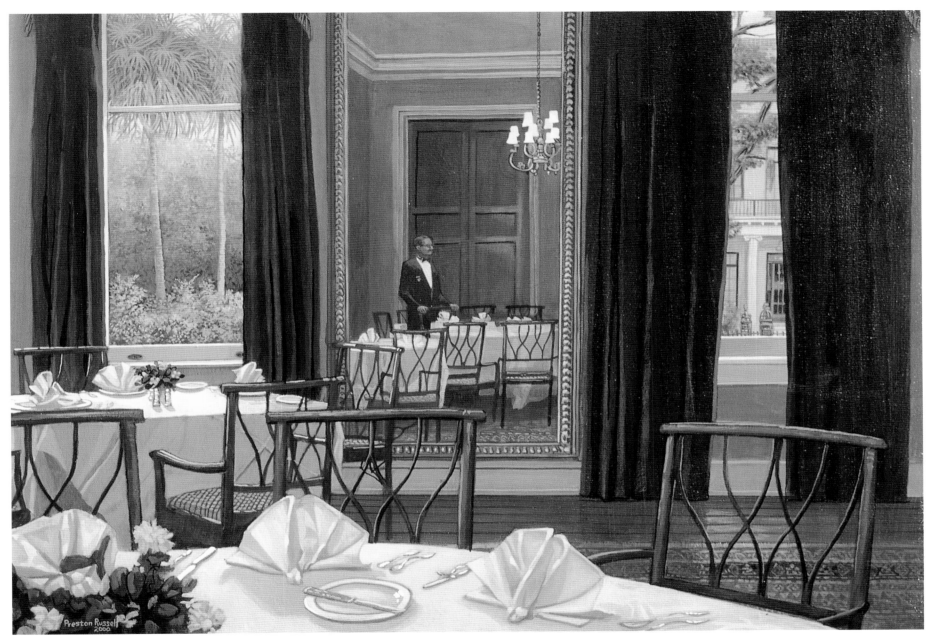

Parlor floor, the Oglethorpe Club, Savannah
This social establishment is over one hundred years old, and seems older. The employee is named Bratton Wright, who seems to
wait for diners from the 19th century, a less-questioned age of old world gentility that is disappearing.
Collection of Mr. & Mrs. Frederick Muller, Savannah

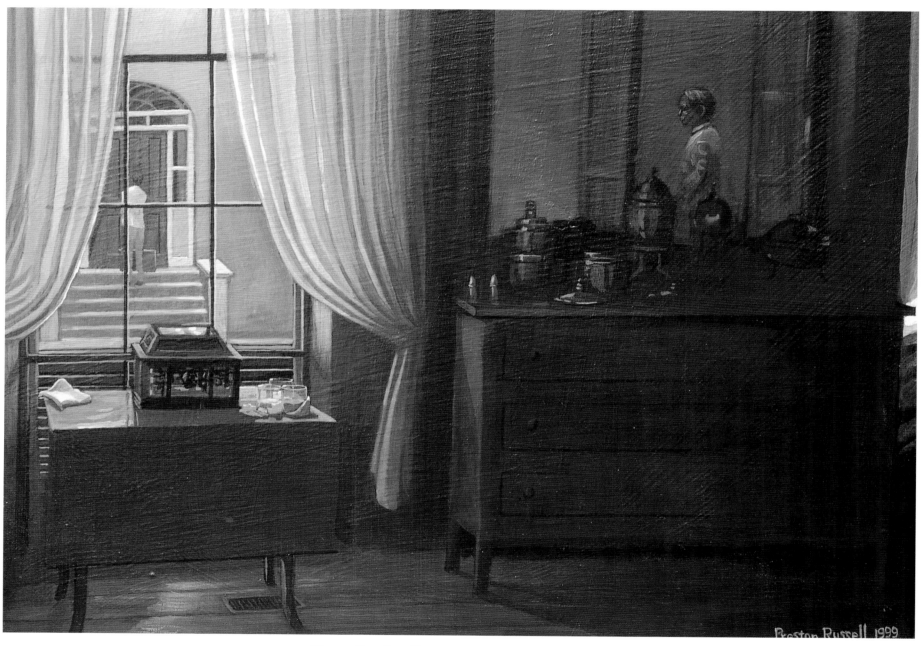

Harper-Fowlkes House, Barnard Street, Savannah
This was just after a social gathering in the headquarters of the Georgia Society of the Cincinnati. The remains of melting drinks sit on an end table. Outside, a young person with suitcase stood at an anonymous door, knocking.
Collection of Mr. & Mrs. Frederick Muller, Savannah

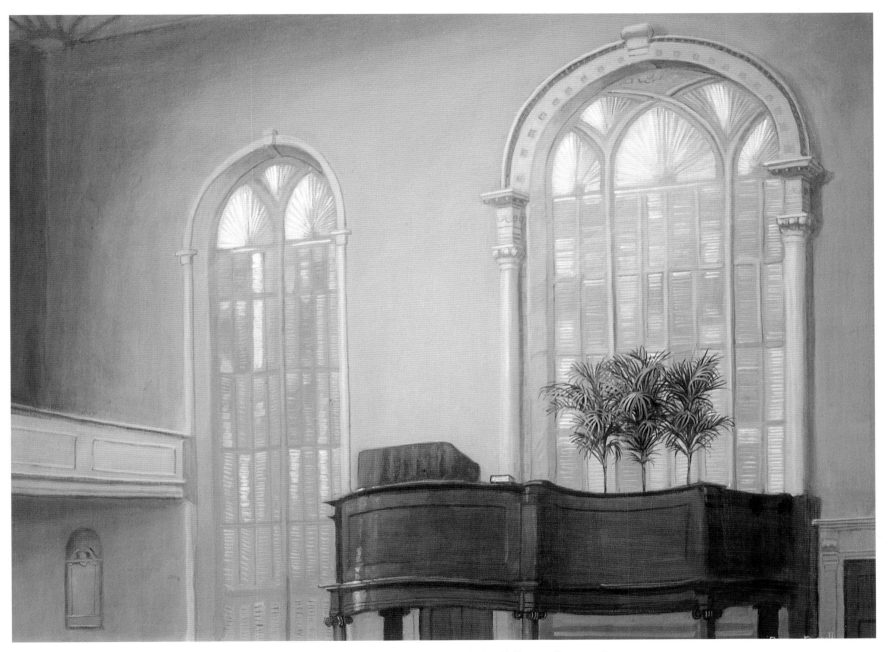

Independent Presbyterian Church, Bull Street, Savannah
With congregational roots that extend to before the American Revolution, this magnificent church was finalized in 1819.
Beyond architectural sweep, I have often been drawn to the three palms behind the pulpit. They live in embracing
refrain, like the Trinity. Man's reach for grandeur, God's simple splendor.

53

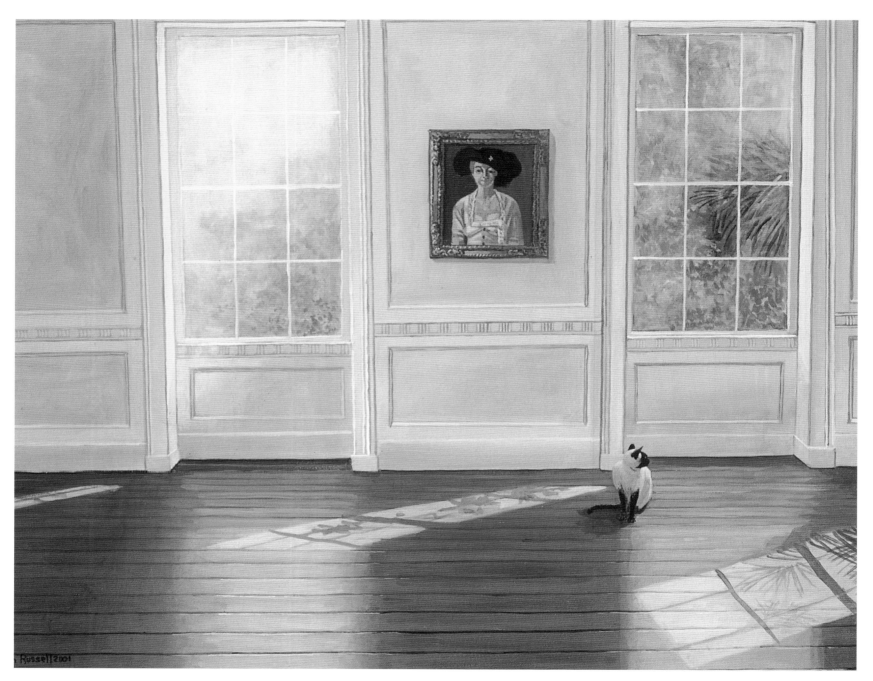

Interior in Beaufort, South Carolina

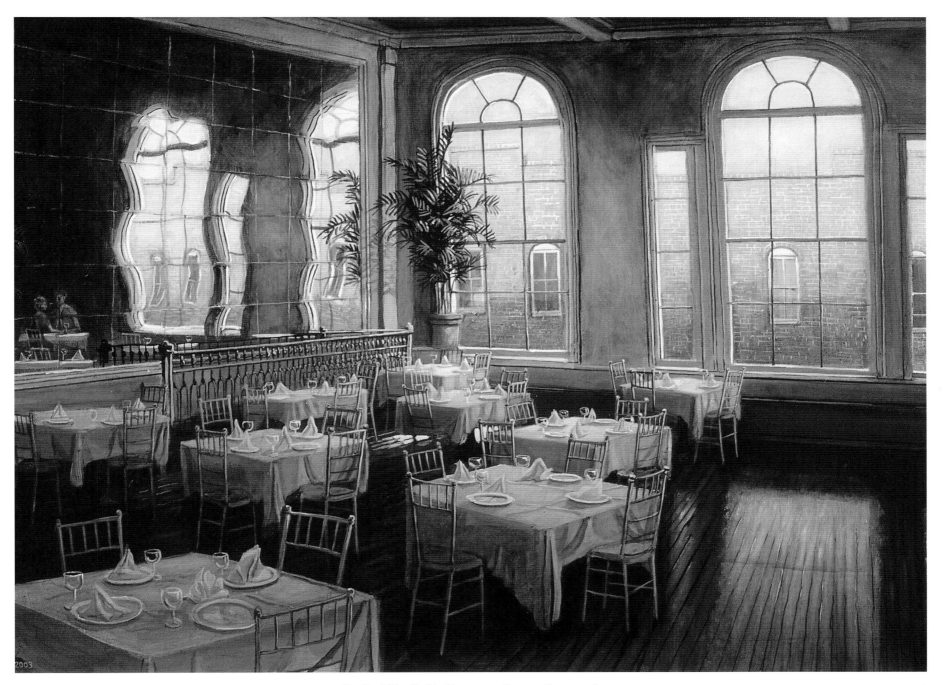

Garibaldi's Café, Congress Street, Savannah

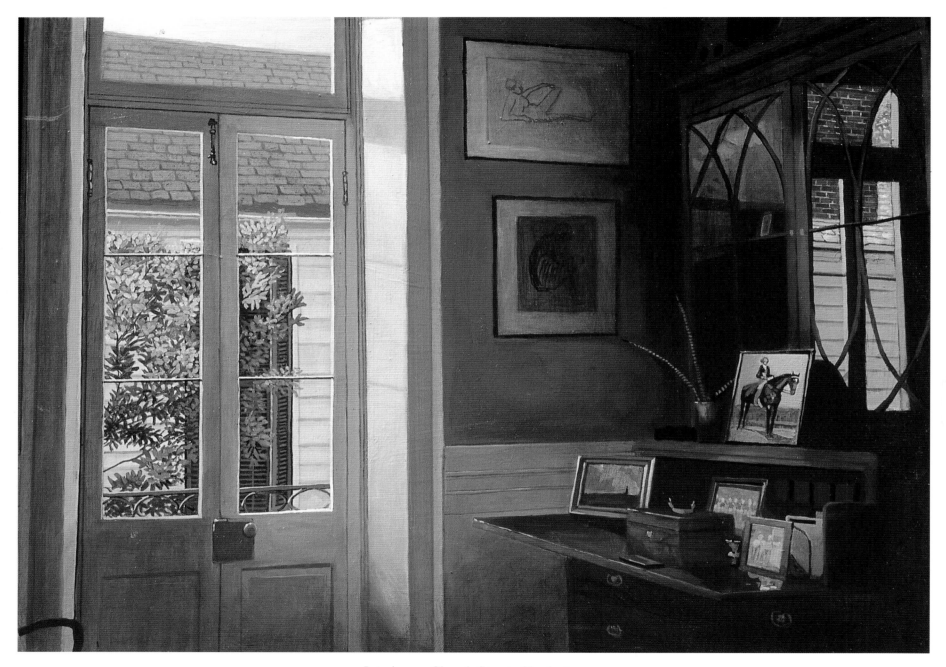

Interior on Church Street, Charleston
Collection of Mr. & Mrs. Warren Spieker, Jr., San Francisco

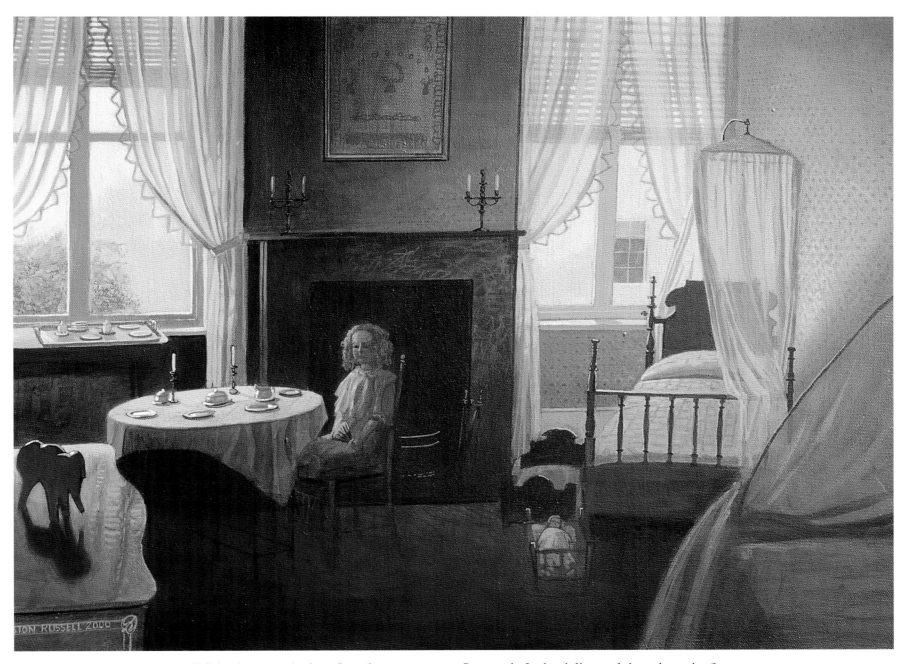

Children's room, Andrew Low house museum, Savannah. Is the doll nostalgic or haunting?
For me there is an aspect of unexplainable dread, like a childhood nightmare.
Commission by the Georgia Society of Colonial Dames

Interior with houseplant and black cat

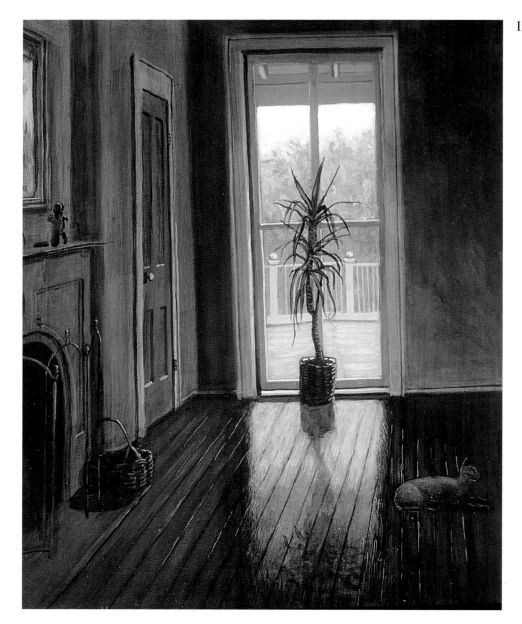

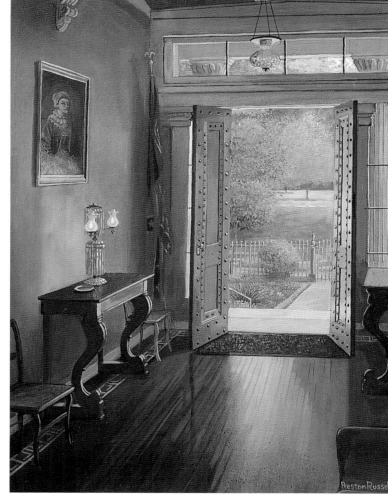

Entrance hall, Andrew Low house museum, Savannah
Commission by the Society of Colonial Dames;
collection of the Morris Museum, Augusta

58

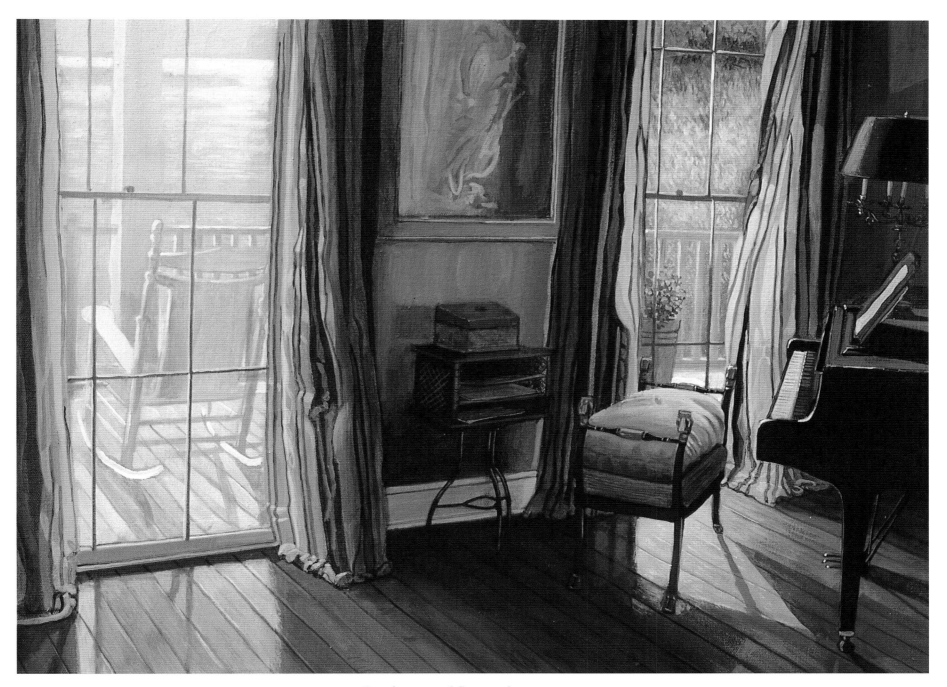

Interior around Savannah waterways
Collection of Dr. & Mrs. Sidney J. Bolch, Savannah

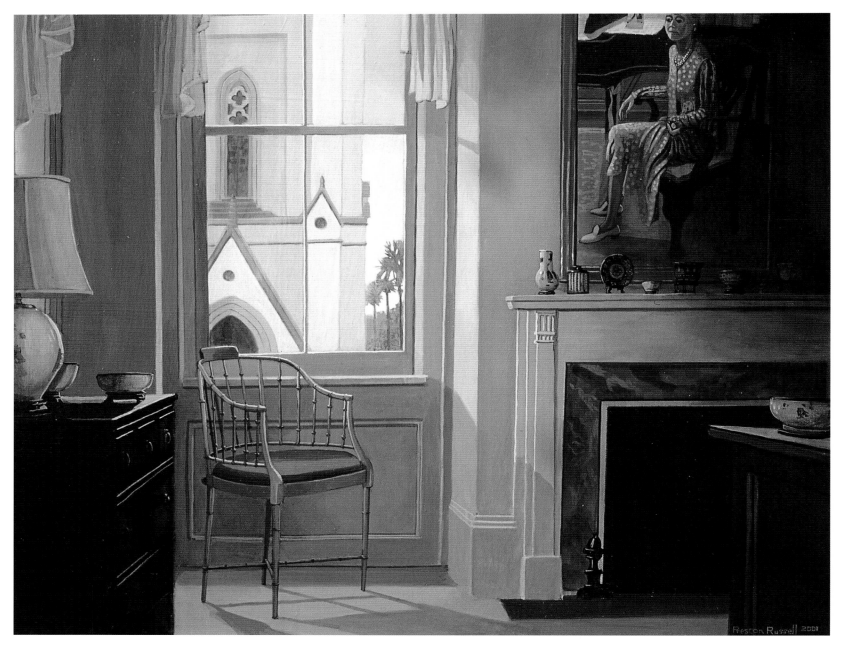

Interior on Abercorn Street, with Cathedral of St. John outside the window
Collection of Mr. & Mrs. Bruce Capra, Savannah

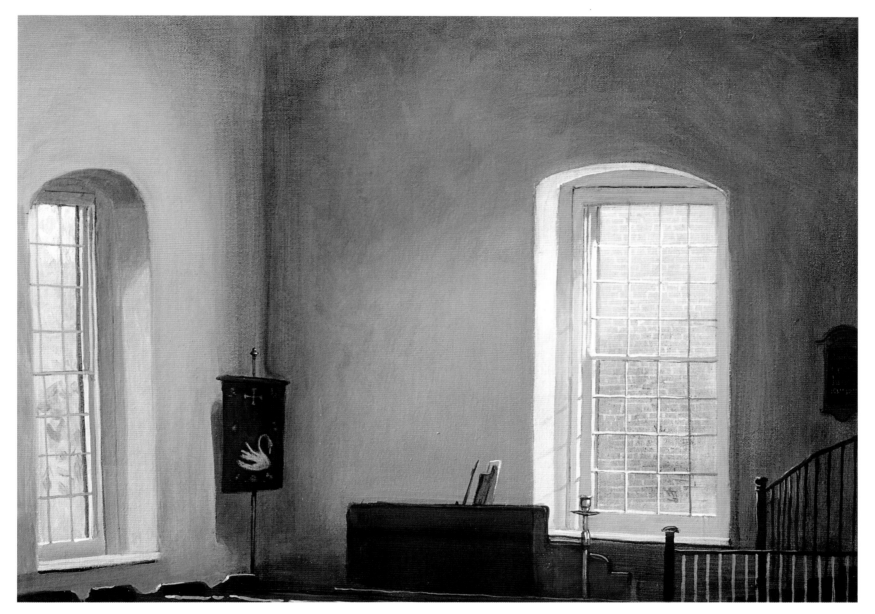

Interior of Salzberger Church in Ebenezer, near Rincon, Georgia
Built in 1769, this is the oldest standing church in the state. Evidence of hand prints remain on the ancient bricks. Fleeing religious persecution in Germany, the Salzbergers settled near Savannah, but wished to remain a bit isolated, to keep their culture intact. The swan, symbol of Martin Luther, is on the banner in the corner, as well as atop the church as a weather vane. It has several musket ball holes through it, a legacy of target practice by British troops during the late 1770's. The church temporarily served as a stable for British cavalry. It splendidly endures as a house of worship today.

PEOPLE

When it comes to depicting people in their own environment, I am most arrested by the works of Edward Hopper. He often exposed the alienation between people and their surroundings—disturbing and existential—as if they were isolated on another planet. Andrew Wyeth achieves the same effect, the insanity of the ordinary, although he can be more affirming than haunting, compared to Hopper. Although I constantly analyze their paintings, I realize their genius is far above some rote compositional formula or gimmick. Yet the *idea* of a Hopper or Wyeth is always in the back of my head. As I work through the painting, I come to greatly admire that subject, the bravery of an individual passing through this life, like no one else before or after. Whether haunting or affirming, the challenge is to avoid the vice of condescension. There is the pandering trap of cliches, including the raving romanticism of the 19th century, full of visual morals, or the Ash Can School of the Depression era, littered with social commentary and preachiness. When subjects project their own integrity, that is more than enough for me. If my painting is successful, the figures truly exist on their *own* terms—not mine or some interior decorator. They allow us to share their life, even if for one moment in time. Then they too will move on, never to be quite the same again.

Over the decades, my human subjects have tended to be of the black race. This has not been a conscious decision, although a former art professor told me long ago that even the most average black person sitting on a porch has a regal aspect. Perhaps that is it. My subjects have tended to be average people, black or white, but average people in their unique space, a space which defines them. I never know what that will be until it is revealed, beyond my contrivances. Abraham Lincoln observed that God must love ordinary people, because he made so many of them. They surely make strong subjects, wherever I am fortunate to find them. I have encountered many proud, capable people, confronting me and the ultimate viewer, the audience. These subjects would be dumbstruck to be considered quaint, picturesque—or ordinary. There is that elusive uniqueness of one person and place, "a wonder and a surprise, ever *springing* in the soul," to borrow a line from Khalil Gibran's best known work, *The Prophet*.

Opposite Page:
Woman on Nassau Street, Charleston
What is she waiting for?

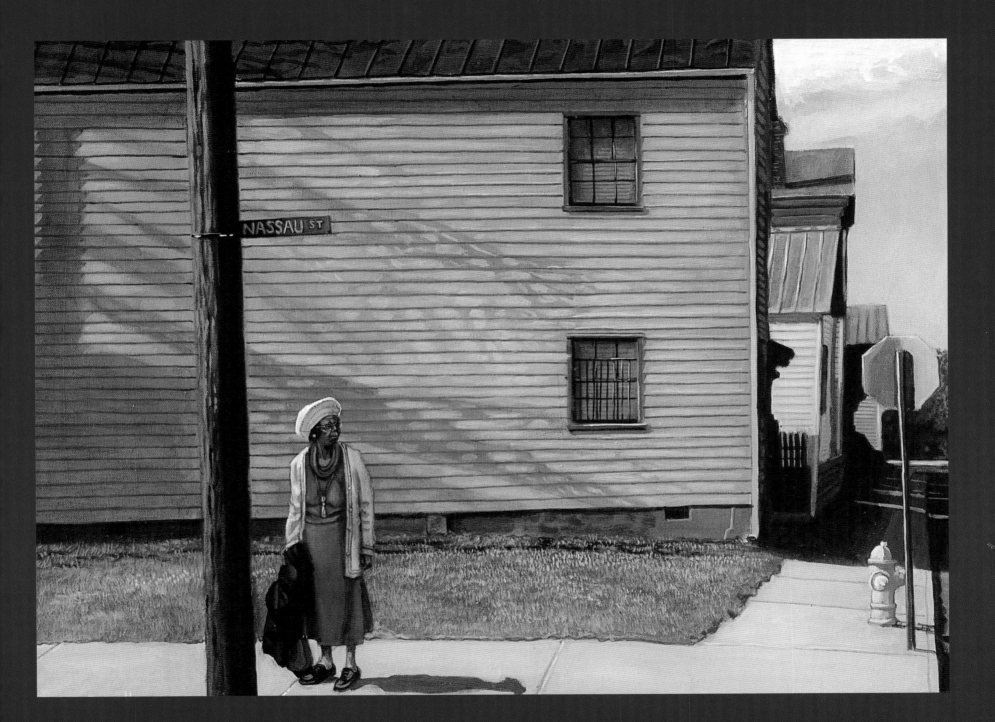

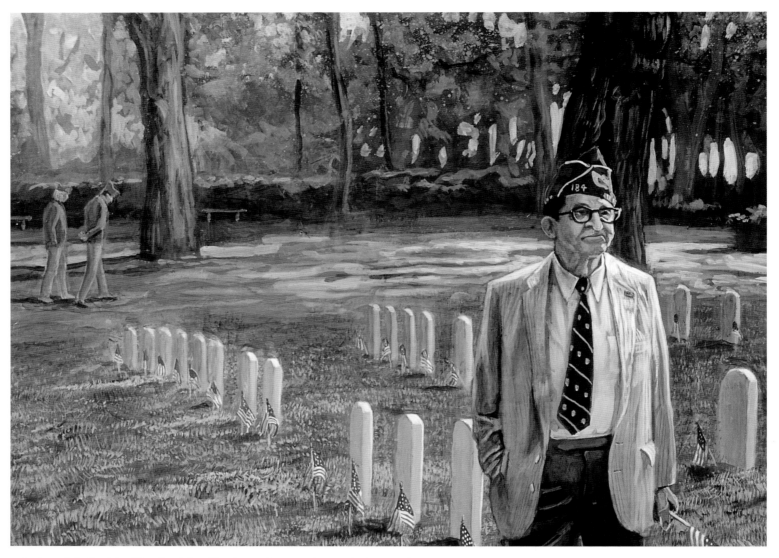

Robert McCorkle, Head of the Chatham County Commission during the 1980's, will be remembered as a Cracker, the polite term for redneck. He even inspired a Cracker Day celebration during his tenure. Like myself, Crackers come from a primal Scotts-Irish gene pool, dirt-poor immigrants in the beginning, desperate British derelicts, who sought a new life in America. No less than blacks, many served their time as indentured servants, bought by the head (like five pounds each back in 1733). Some do answer to Bubba (which in the south secretly means a mensch, but don't tell anyone up north). Mr. McCorkle was not cosmopolitan, a strength and weakness. He was what he was, a simple, honest man, a baker who ran for office, causing something regional to respond: Crackerness. Here I caught him as an everyman patriot, attending a Veteran's Day memorial in Bonaventure Cemetery. Robert McCorkle recalls my blood heritage, warts and all. In later years he became a colorful artist, which shows just how contrary Crackers can be.

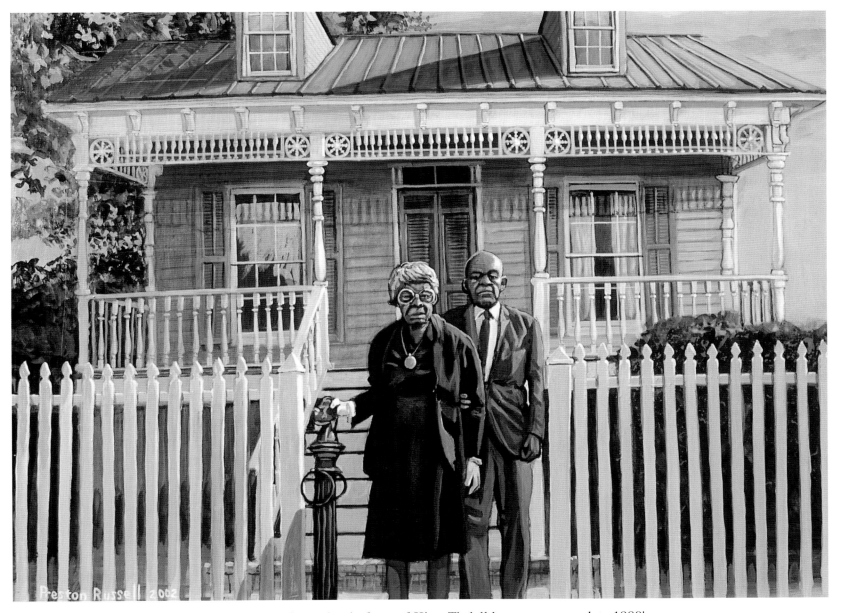

W.W. Law and his mother in front of King-Tisdell house museum, late 1980's

I depicted this in ancient byzantine tradition, symmetrical, formal, a bit stiff, with timeless stability, like an icon. This is the way I recall Mr. Law, an icon of black pride, or Negro pride, reflecting the pre-politically correct term he and Martin Luther King Jr. grew up saying, like I did. He was a mailman by occupation, who was a N.A.A.C.P. leader in Savannah's peaceful integration during the 1960's. Mr. Law long ago decided that he would be addressed as W.W (instead of Wesley Wallace), which during the bad times was less likely to have "boy" attached. Mr. Law demanded respect and courtesy, and he gave it back, like any southern gentleman.

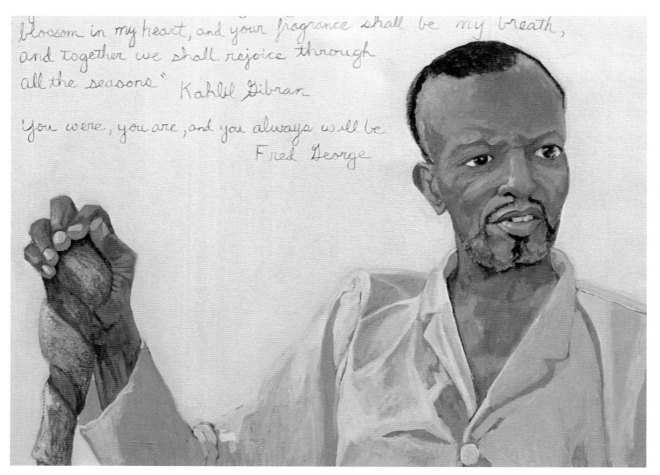

"blossom in my heart, and your fragrance shall be my breath, and together we shall rejoice through all the seasons" Kahlil Gibran

You were, you are, and you always will be
Fred George

Fred George, of Pembroke and the world
Collection of Mrs. Dorothy George

Right: Family reunion in Pembroke, Georgia, 1976
This is the massive family reunion of Fred and Dorothy George. Note the clashing diversity of generations. Fred is standing behind his adolescent son, Shalom, in the red and blue t-shirt. Shalom would be middle-aged now. It was just yesterday—where does time go? Words cannot express the spiritual guidance Fred gave me at a formative time. He had traveled the whole world, a sort of black Zorba the Greek, a voyager, a Ulysses. Fred was the wisest teacher I ever knew, a lover, who expressed love for all mankind. When he died, I kissed his cool forehead and wept like a baby. But as Fred often said, "you were, you are, and you always will be."

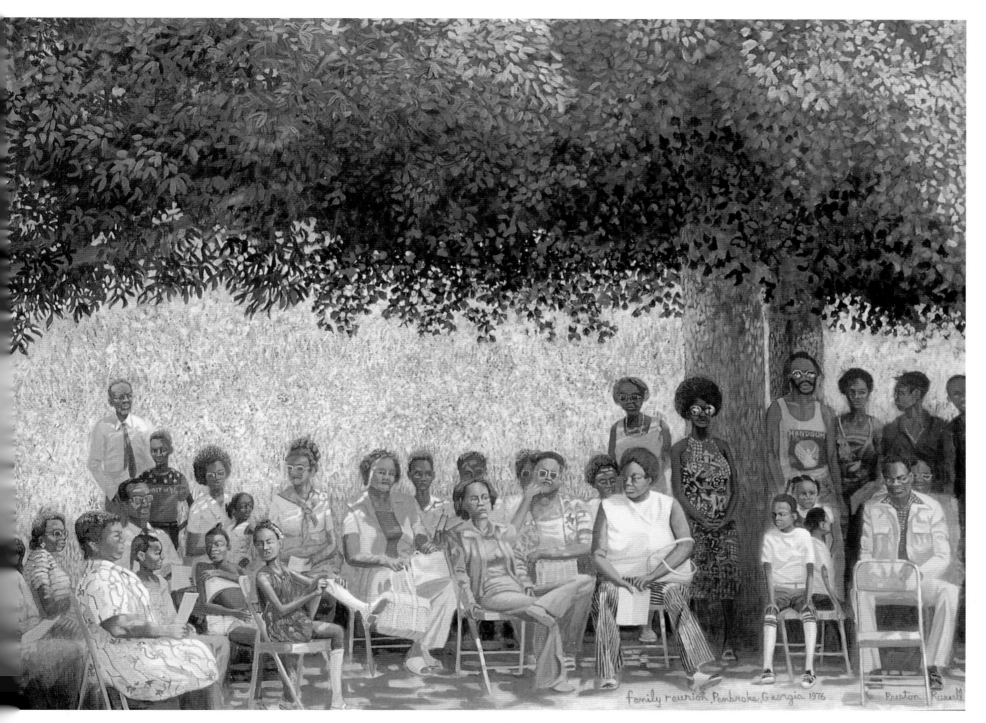

family reunion, Pembroke, Georgia, 1976 Preston Russell

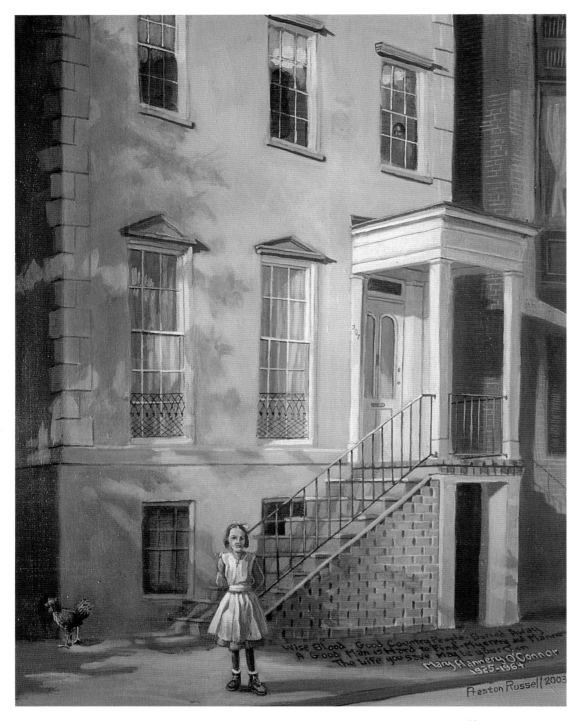

207 E. Charlton Street, home of writer
Flannery O'Connor, Savannah

Mary Flannery O'Connor was born in 1925 and raised here, before moving in adolescence to spend most of her brief life in Milledgeville, Georgia. She never forgot her pet chicken, which could walk backward, later accumulating a menagerie of exotic fowl—including more than 30 shrieking peacocks. Flannery was raised a staunch Catholic, attending Saint Vincent girl's school a short block away, always escorted by her protective mother, who also maintained a strict list of approved little friends. The imposing shadow of Saint John's Cathedral just across Lafayette Square informed Flannery's life, as well as her literary imagination. O'Connor's works are usually categorized as Southern gothic—even grotesque—a feminine William Faulkner with bizarre bite. As she cryptically observed, "I have found that anything that comes out of the South is going to be called grotesque by the Northern reader—unless it *is* grotesque—in which case it is going to be called realistic." Flannery O'Connor died prematurely at age 39.

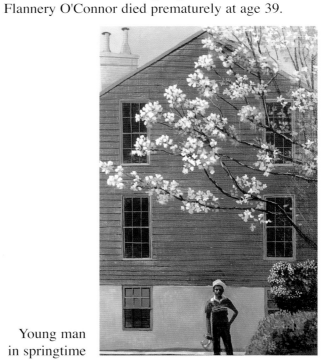

Young man
in springtime

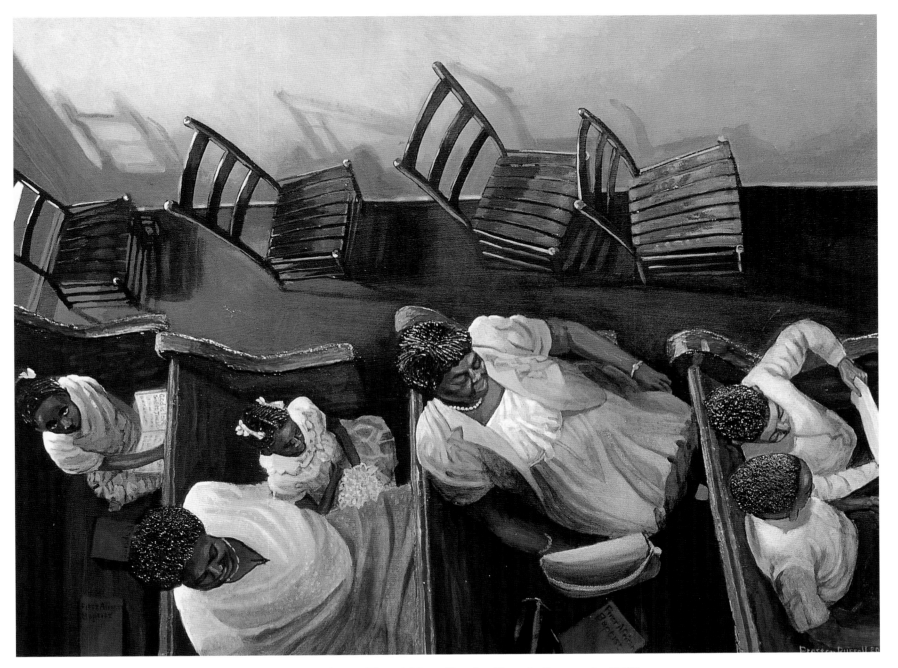

Sunday morning at First African Baptist Church, Savannah, 1980's

This congregation has roots back to the American Revolutionary era. The grandmothers represent mountains of tradition. Notice the little girl on the back row, shyly looking up at me, the intruder. *Original version in the collection of Mr. And Mrs. Emerson Cowart, Savannah*

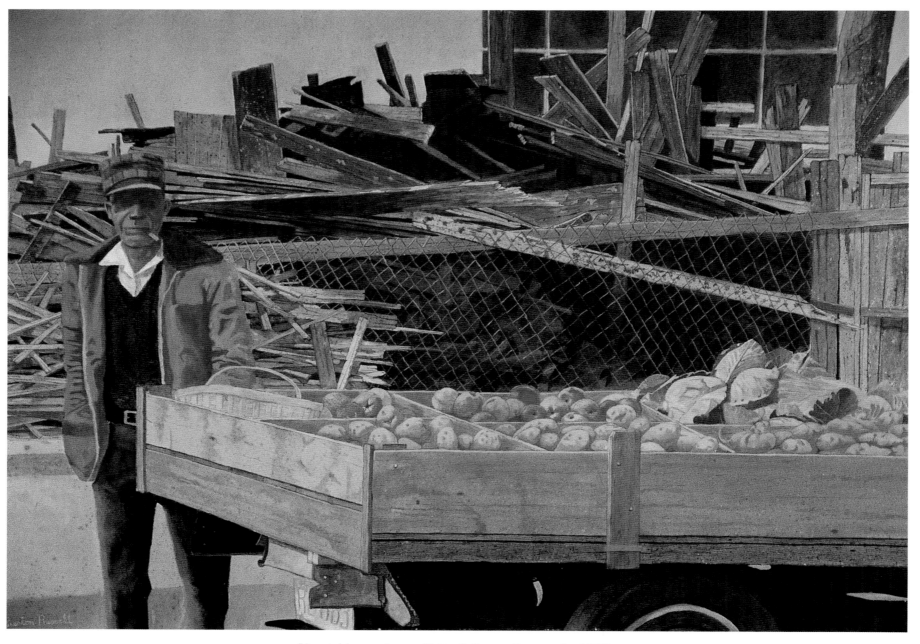

Vegetable vender on Tattnall Street, Savannah, 1970's
I am proud of this painting because it was one of several chosen by the French government in their Paris salute to our American Bicentennial in 1976.
It was the first time I went to Paris—but never the last—by the spring in my step always an American in Paris, the city of romantic excitement.
Collection of Ms. Lindsay Russell, New York

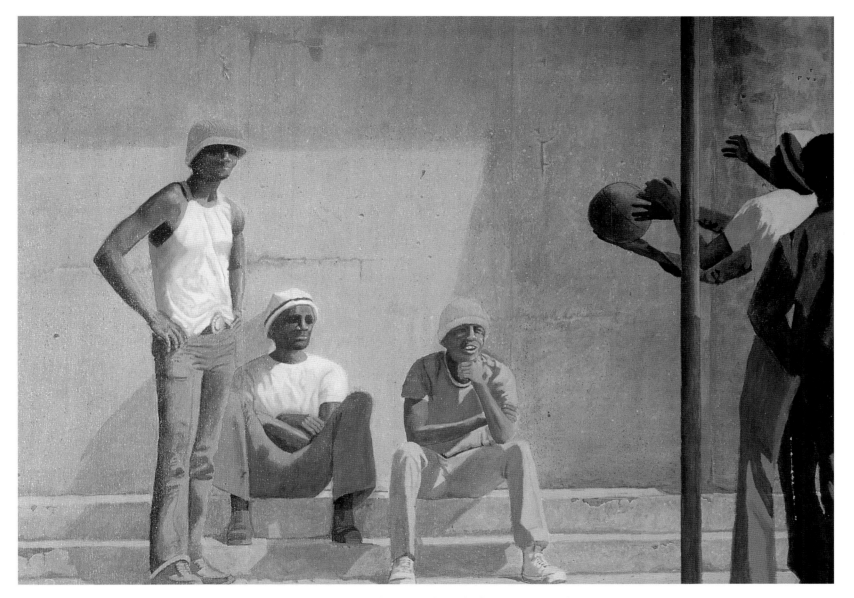

Basketball players in Forsyth Park, Savannah, 1970's

I used to play a lot of ball with these guys. Three of them are waiting their turn in the game called "Winners," when you stay on the court for as long as you win. No fouls are called, so nobody fouls on purpose, and never hard—although the accidental elbow to the head can really sting. They called me Lamb, after Bill Lambier of the Detroit Pistons, a slow, ugly player with "white man's disease"—no jump—no moves. My son Alex was much less afflicted, winning Most Valuable Player his senior year in high school. Of course they always chose him over me for Winners.

Collection of Mr. Alexander Preston Russell, Jr., Boston

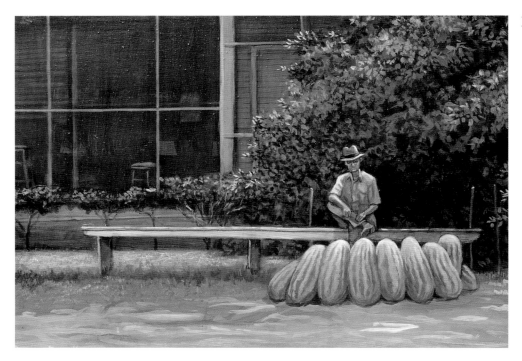

Man with his watermelons for sale, Bluffton, South Carolina, 1970's
How could he actually sell them?
They struck me as almost like his pets.

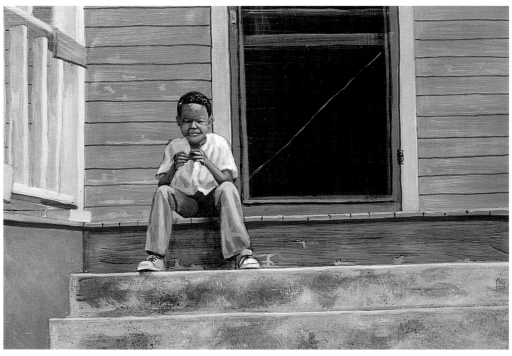

Young man on steps, Victorian district, Savannah

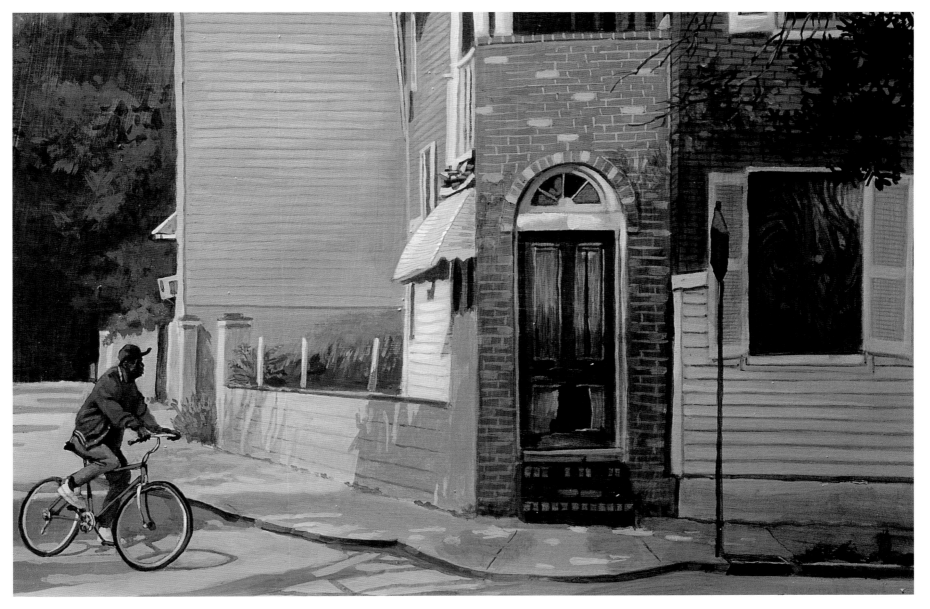

Man on bicycle, in upper Charleston

I am warned that this part of town is very dangerous, so few artists venture there. I too have sensed danger there—a sinister shunning—even shouted threats. One resident whose trust I finally gained told me I look like some undercover policeman, poking around, spying. Without trying to sound like a social anthropologist, the tragic difference between these areas now and what they were thirty years ago is primarily due to street drugs. There is no trust, only deadly suspicion, and the threat of death itself. Something formerly full of hope is dying before our eyes. The wall is going back up, an American tragedy: them versus us.

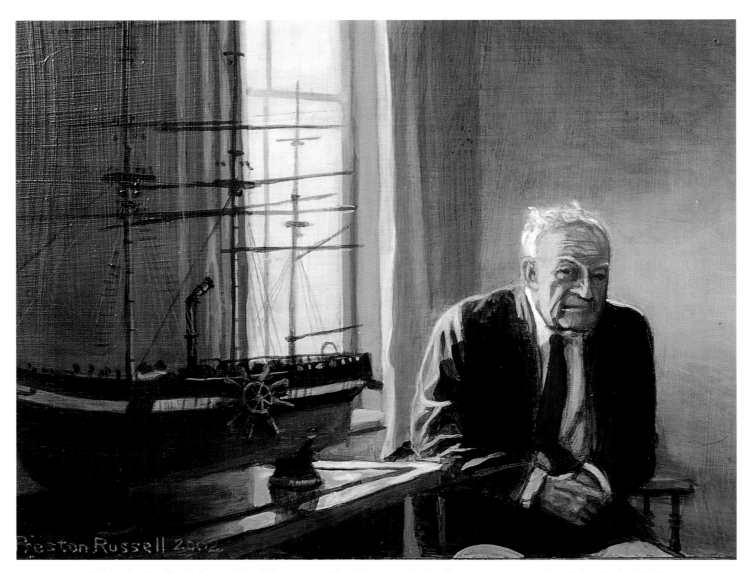

Malcolm Bell, with model of the steamship, *Savannah*, the first one to cross the Atlantic in 1819

Malcolm had a particular affection for this vessel, having chronicled her history, and also was head of the bank for which the vessel was the emblem. He had many guises: businessman, documentary photographer, author. For me he was a generous mentor, an amateur historian who shared his exhaustive knowledge, along with his deep passion for the low country. But Malcolm ruined his amateur status with the publication of *Major Butler's Legacy*, a classic standard on regional slavery. Some of the subjects he, along with his wife Muriel, had photographed as a young man. He told me he once got mad when—after eight long years of exquisite research—some stuffy scholar informed him it was indeed a major work, but dismissed Malcolm as not academically qualified to have written it. Well, take that, academia!

I recall Malcolm as a square-jawed rock, the best.

Collection of Mr. John Cay, III, Savannah

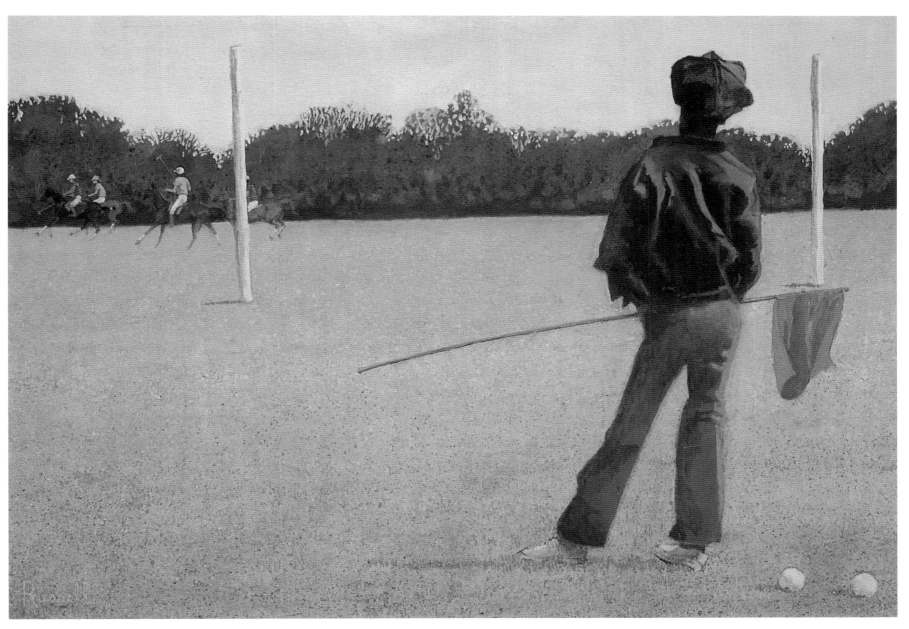

Young score keeper at polo match, Hilton Head, South Carolina, 1970's
Collection of the Honorable & Mrs. Dudley Bowen, Augusta

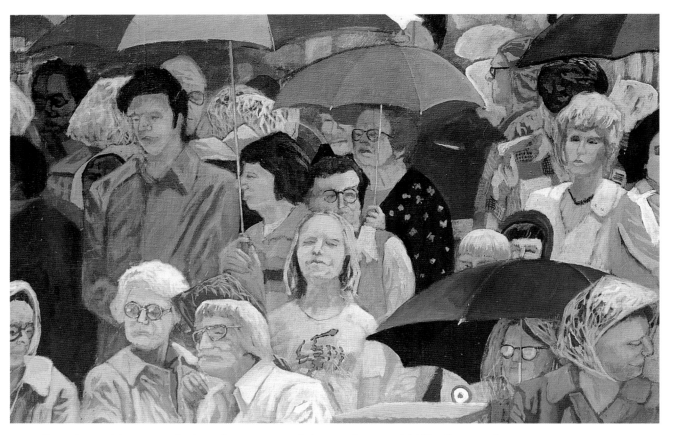

Crowd watching a musical performance on Johnson Square, 1970's, Savannah
Collection of Mr. & Mrs. Malcolm Butler, Savannah

New Orleans Preservation Jazz Hall Band,
Johnson Square, Savannah, 1970's

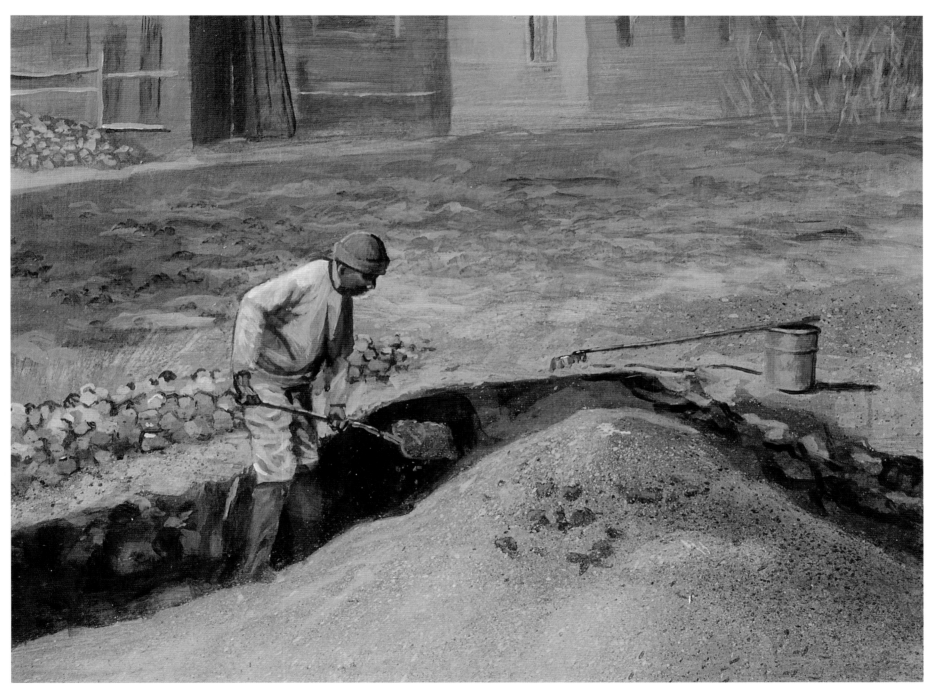

Man digging on the site of the 1779 Battle of Savannah, off Cohen Street near the Sheftall-Levi cemetery, 1970's. This was one of the bloodiest battles of the American Revolution, hallowed ground where hundreds of French and Americans still lie in mass unmarked graves. A ghastly defeat for the Franco-American alliance, their legacy remains largely forgotten to history--phantoms to popular memory--except for a dogged few.

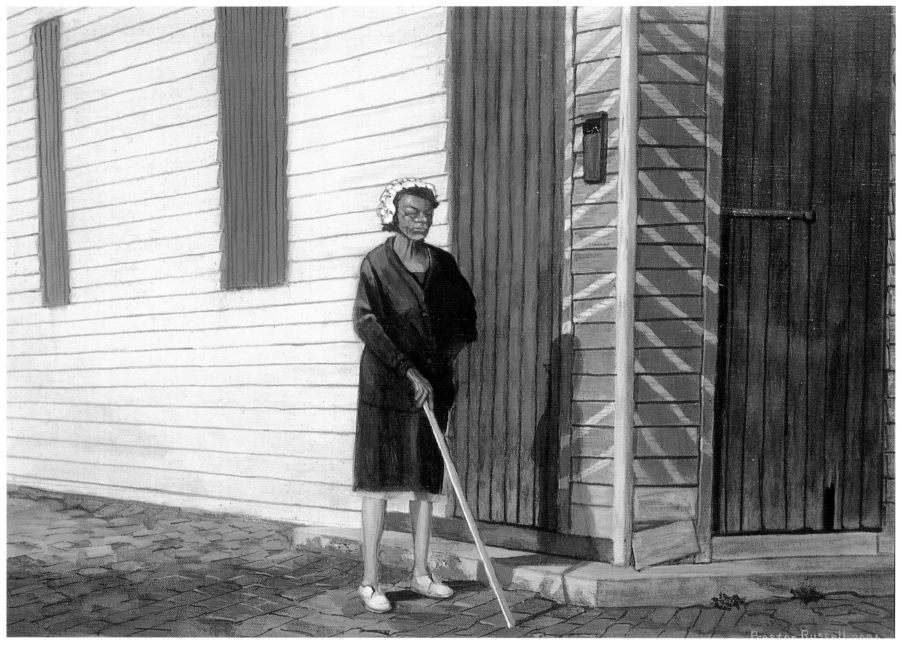

Woman with cane, Oglethorpe Avenue and East Broad Street, Savannah, 1970's
Original version in collection of the Georgia Medical Society

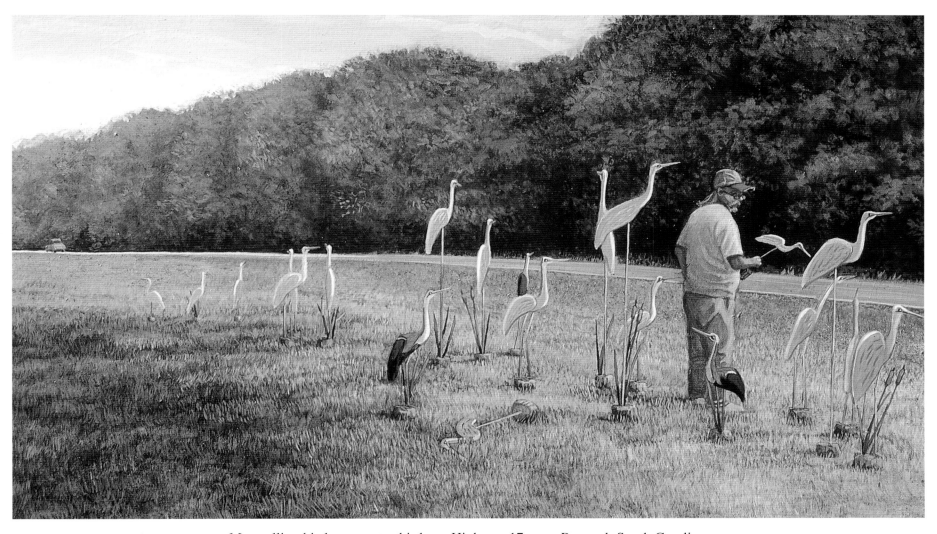

Man selling his low country birds on Highway 17, near Ravenel, South Carolina
His name is Ray Van Hook. The last time I saw him, he said business was bad. Yet he is still hanging on,
enthusiastically making those birds. What if Ray gives up? Would his birds fly away?

The autobiographical painting on the opposite page is based on a photograph taken by my grandfather, Eugene C. Elam, circa 1910, down in the low country near Jacksonville, Florida. Dressed from the 19th century, his austere mother-in-law (wife of a Presbyterian minister) stands before her daughter and his recent bride, Julia Harris Elam. Grandmother Elam—Nana—was one of my favorite ancestors. Grandfather Elam was another favorite, a dignified comedian who lived with verve. He had European panache, who in adulthood changed the "C" of his middle name to Chesterfield, because it sounded more British. My mother and I lived with them while my father was far away during World War II as a combat surgeon, in North Africa, Sicily, and bloody Italy. He was away a long time, his return a shock to me, an alien to his child, like so many war daddies. After Grandfather Elam died prematurely when I was four years old, Nana sustained herself for over three decades by running a small boarding house in Nashville, Tennessee. In the south, this is euphemistically called genteel poverty, although she never considered herself poor, which she never was in the ways that counted. Her son Paul was the fix-it man, who slept in a tiny cubicle off the kitchen. The room was permeated by the scent of propane gas from the stove, and he sometimes had alcohol on his breath, before dark.

Grandfather Elam, during his "Chesterfield" British phase, a man who dispensed mirth

Treated like the little prince, I visited often. Nana, Uncle Paul and I always caught Saturday night radio (*Gunsmoke*, *The Shadow*, and *Gang Busters*, with that immortal opening of screeching tires and rata-tat-tat machine gun—followed by **GANG BUSTERS!**). During the summers, we clustered around the small electric fan, which emitted more noise than breeze, like a distressed airplane. I was given the choice bed

Grandmother Elam, Nana, her normal dignity destroyed by her husband photographer

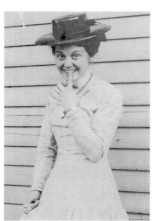

closest to the window. You learned to rotate your pillow during the night, seeking the cool side, which did not last long. Often Nana had trouble sleeping, and Uncle Paul would take her for long rides in the middle of the night, until her night fears calmed toward dawn. We played Rummy and Old Maid after dinner, where I learned the wiles of bluffing when the queen of spades wound up in your hand. There was mirth, as one, when we fooled each other, thrilled by the other's clever trick. The big event was a movie down the street in Hillsborough Village—especially if a western was playing! I remember the actor Joel McCrea, and I developed a (very) pre-pubertal crush on Virginia Mayo. They both wound up as shot-dead lovers in "Colorado Territory," my first introduction to tragedy, long before college, Shakespeare, and real death. I became close friends with a cranky old parrot, who resided at Jone's Pet Shop—along with the overly tolerant Joneses. I can still see the three of them like family. I also used to buy one dozen donuts from the bakery down there, and then would eat every one of them myself on the walk back. They cost all of forty-eight cents, of course from Nana's money. The donuts were extra big too, my huge sack weighing several pounds at least. Once my mother tried to teach me manners, reminding me to offer at least a little something to others. It was a traumatic introduction. When Nana actually *accepted* one of my twelve donuts, I burst into heartbroken tears.

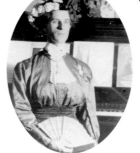

Grandfather Elam, dressed as Nana. No gag was too outrageous.

My mother, Nancy Elam Russell, and me during World War II

What more can one say about a special childhood. Nana and Paul's house and most of the neighborhood are long gone, paved over by some enormous traffic exchange. Now it seems like nothing but concrete ever existed there before. I cannot even estimate where their home used to be, where all of us sat on that small porch to catch the breeze and sights off 21st Avenue. My father's childhood home in Tennessee is now under a lake. He and mother are also gone. Every one is gone, except in priceless memory and image.

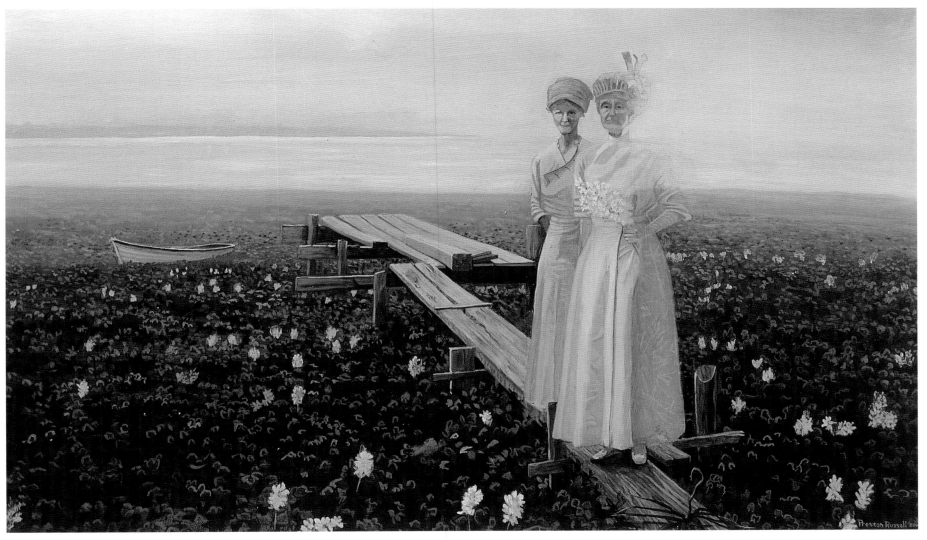

Low country mother and daughter

ABOUT THE AUTHOR

Born in 1941, Preston Russell was raised in Clarksville, Tennessee. He studied art and literature at Tulane and Austin Peay Universities, before graduating from Vanderbilt Medical School in 1966. After moving to Savannah in 1973 to practice medicine for nearly three decades, he continued his painting, being a founding member of Gallery 209 in the 1970's. In 1976, the French government chose three of Russell's works for the American Artists in Paris exhibit, part of France's cultural salute to the American Bicentennial. Over the years, Preston has been featured in many exhibits in the low country. His works are in homes throughout the nation, as well as the Morris Museum in Augusta. Now retired from medicine, Russell is presently represented by art galleries in Savannah and Charleston.

Dr. Russell's other passion has been history, being Savannah's Chairman of Georgia's 250th Anniversary commemoration in 1983. He has served as a curator of the Georgia Historical Society, currently serving on the board of the Georgia Coastal Heritage Society and the TelFair museum of Art. In 1992, he and his wife Barbara published *Savannah: A History of Her People Since 1733*. He also served as chief editor and contributor on a recent national school text of the Colonial and Revolutionary periods, *Why America Is Free*, sponsored by the Society of the Cincinnati and the Mount Vernon Association. He has published historical articles in diverse publications, including *American Heritage Magazine*. His pending book is *Lights of Madness*, dealing with the mystery of Joan of Arc, to be released in 2003.

But Preston's proudest accomplishment is being the father of Lindsay and Alex Russell, which was due in no small part to the total cooperation of their mother, Nancy.

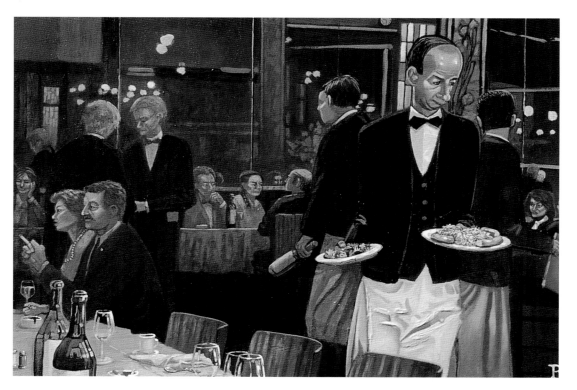

Preston Russell and his wife Barbara (left) enjoying Paris
yet again at Brasserie Lipp.